The Inner Mirror

Conversations with Ursula Hauser
Art Collector

The Inner Mirror

**Conversations with Ursula Hauser
Art Collector**

**Edited by Laura Bechter and
Michaela Unterdörfer**

Hauser & Wirth Publishers

Contents

Preface

How does a private collection of art acquire shape? How does it express the personality of the collector? What factors determine a collector's view of art? And what responsibility do collectors take for what they have collected?

In recent years, we have explored questions of that kind in a series of projects and publications with private collectors: Wilhelm Schürmann, the Lauffs Collection, the Reinhard Collection, Ingvild Goetz, Sylvio Perlstein, and the Panza di Biumo family. It has been a long-cherished wish to explore those same questions as they relate to a collection that is closely associated with Hauser & Wirth: the Ursula Hauser Collection.

Ursula Hauser's interest in art and collecting goes back to the 1950s, when she acquired her first sculpture while still a young woman in training, studying textiles. Over the ensuing decades, she has thoughtfully forged one of the world's most important private collections of modern and contemporary art. Her passion for collecting is focused on painting and on what she calls "the other sculpture." It is not the pleasing or "beautiful" picture that fascinates her but rather work that may be raw, unpolished, and, on occasion, even disturbing. Hauser instinctively seeks out art that touches her emotionally, that is both personally and intellectually challenging.

The moment she acquires a work, she has it installed or mounted in a suitable place in her proximity. She is a collector who lives with her art and engages in an active exchange with those who have created it. Thus, studio visits have become a fixed ritual, an indispensable constituent of her encounters with art. They exemplify her need to become acquainted with the people behind the art, to find out more about their lives and thoughts, and to investigate the untold ways in which the human condition may acquire concrete shape in the form and material of a work. Many close friendships with artists have grown over the years, and it is telling and, indeed, extremely impressive, to hear this collector speak lovingly of her "artist family," revealing how deeply she values these relationships that are of such crucial significance for her.

Parts of the Ursula Hauser Collection have occasionally been presented to the public but the collector herself has consistently remained in the background, preferring to showcase the art and those who make it. Not so in this book. In conversations with her, we wanted to explore what motivates her and how she became the passionate collector that she is today. She told us about her roots and her family, about her interest in regional practitioners and about founding a local gallery in eastern Switzerland. We learned about numerous trips and encounters with the artists represented in her collection—and, above all, about her acute awareness of the responsibility she carries for the works that have been entrusted to her as a collector. To do justice to this responsibility, Ursula Hauser invests a great deal of thought and energy into showing and communicating to others the art she has collected.

In the course of our conversations, a few larger groups of work proved fruitful as themed highlights to describe the distinctive profile of this collection. This also enabled us to achieve our goal of demonstrating its uniqueness. We know that a portrait of this kind is inevitably fragmentary. The artists we have highlighted here must necessarily stand in for the many, many more that are an integral part of the whole.

Not only is the Ursula Hauser Collection itself unique, it also holds a unique position in the field of contemporary art collecting, testifying, as it does, to Hauser's explicit interest in the experiences and reflections of female sensitivity that are distilled and expressed in art. This has led, over the years, to a collection that particularly accentuates women's art. Time and again, our conversation returned to the fact that women artists are underrepresented and have fewer opportunities to take advantage of their artistic potential. This has changed in recent years with a growing interest in women artists and questions of equal opportunity, not least because of the courageous and determined activities of private collectors. It would be mistaken, however, to attribute a feminist political agenda to the Ursula Hauser Collection. The collection has no agenda, hidden or otherwise!

For decades, Ursula Hauser has been an important patron, sponsor, and spokesperson for women artists. In her, they find an open-minded, sensitive, and personally committed ally. She is fully aware of the indispensability of art and the need to provide space for the stories that take concrete shape in artworks. What is thus manifested in art is by no means specifically feminine; it is profoundly humane, as aptly put by Meret Oppenheim, an artist who plays a key role in the Ursula Hauser Collection: "It is always the entire human being who speaks through a great work of writing, art, music, or philosophy. And that is both male and female."

Art as a mirror of humanity: this is impressively embodied in the Ursula Hauser Collection.

Michaela Unterdörfer

In Conversation

Laura Bechter, Michaela Unterdörfer, and Ursula Hauser

Ursula Hauser, 1957

St. Gallen: Childhood

MICHAELA UNTERDÖRFER Ursula, let's start with the fact that we are having this conversation at home with you, in your kitchen. With a lot of personal things, photographs of your children, Manuela, Urs, and Sandra, and your grandchildren; art is mounted on the walls; there is a vase of flowers on the table, next to them a stack of books, invitations, letters. Is this a particularly important place in your house?

URSULA HAUSER Yes, with a view of the outdoors, of the natural surroundings. Very close to the fridge, to where the food is. A big wooden table with lots of room to lay out everything you need—I like that. A table can never be too big. Everything within reach. I receive a book or a catalog practically every day. It's the most important place in the house!

MICHAELA You've been living here for over thirty-five years.

URSULA I have to take a detour, to explain why I'm here. I grew up in this area. Our art teacher used to take us to the river Thur. It's an absolutely beautiful recreational area with water and hills. On the way, we often passed this house. It struck me, even as a small child, and I always wondered who lived in it. What kind of special people? And every time I took this path, I saw the house—again and again. Then thirty-five years ago, I was reading the newspaper at some point and saw an ad: "Bauhaus building for sale near Uzwil on the Thur." Something clicked, and I decided to call. The owner had already moved out and was living in a retirement home. The house had been empty for two years and she was determined to find someone she found suitable. She had no children. A number of people had inquired for a wide variety of commercial uses, some of them rather dubious. The owner was a distinguished elderly woman from the textile industry. Everything just seemed so right, and she said, "Good, let's meet this afternoon, I'll come with my nephew. What you've told me sounds good." We looked at the house together and after an hour, she said,

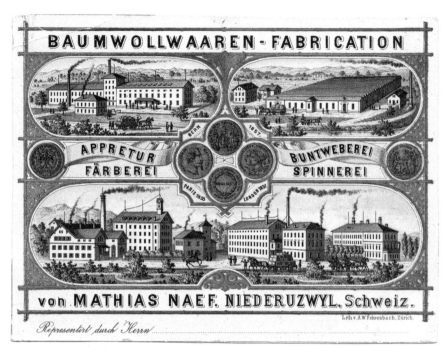

Advertisement for the Mathias Naef Company, 1857

Postcard, 1905

"I've shown the house to so many potential buyers and no one was suitable. But you are. I have always wanted a family to live here again that will appreciate the house I looked after for so many years. I'll sell it to you." Then we closed the deal by shaking hands, and half a year later, after slight renovations, we were able to move in. So here I am, and I'm happy.

MICHAELA You were born in 1939. Where did you grow up and what was your family situation?

URSULA I was born three weeks before the war broke out, the Second World War. My father was serving in the army as a driver for high-ranking officers on the border, which was already under surveillance. My mom was at home alone, waiting to give birth to me. She had to go to the orphanage to give birth because there was nobody to help. My parents were living in Gossau, St. Gallen, at the time, and that's where I grew up. Our circumstances were poor, very poor, like almost everybody else before and during the war! I was their first child and sickly. I was only six months old when I came down with a bad case of pneumonia. It was touch and go; there were no antibiotics or penicillin in those days. But I managed to survive—for the first but not the last time in my life.

MICHAELA What was your relationship with your parents?

URSULA Pretty normal, close. But maybe not like nowadays, not so affectionate. My parents had to work extremely hard. My mother was a professional seamstress. That's why she had a beautiful collection of fabrics at home, remnants that I used to play with and make things out of. The women that she sewed for came to our house. That was customary in those days. There were no boutiques. She would show her collection of fabrics and then, for example, her customer would order a red dress for a wedding. The textile industry in St. Gallen was known for its embroidery, and in Zurich, it was silk weaving mills. My mother had a collection of samples at home and ordered what she needed. Our living room was her studio, with the sewing machine in it from Monday to Friday afternoon.

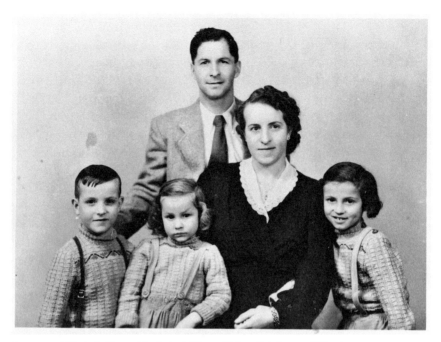

August and Hedwig Fust with their children, Walter, Brigitte, and Ursula, 1945

Ursula, 1962

Then she stopped. All the threads, everything was tidied up for the weekend. We cleaned up together. Usually, the customer could pick up her dress, too. It generally took a week for my mother to finish one. It was haute-couture. Obviously, I learned a great deal.

MICHAELA Did your mother teach you to sew?

URSULA I wanted to learn to sew by myself because what my mother sewed wasn't necessarily my style. It was usually the classical skirt suit, immaculately tailored. I wanted to wear "rags" for a change, just a colorful dress with a belt, or a bikini. As young women, we simply took a couple of remnants and copied what we saw in fashion magazines. That was long before Ursula Andress wore a bikini in James Bond's film *Dr. No* back in 1962. You can imagine how conservative it was in those days. When I made black-and-white Pepita pants as a teenager, I stuck out. I was totally "in."

MICHAELA Fashionable avant-garde . . .

URSULA With practically nothing . . .

MICHAELA Did your mother support you in that respect?

URSULA Yes, but I took a different route; my mother's style was too conservative for me, too classical.

LAURA BECHTER Your father and mother were both born in 1913.

URSULA Yes, and as the son of a farmer, the oldest of thirteen children, my father had no chance to learn a trade. He grew up not far from here, and when he was fifteen, sixteen years old he would walk or bicycle to a furniture factory where he acquired his first carpentry skills. He used to pass this house on his way, too. There was a chalet here before 1928. He watched this house being built, stone by stone, with no crane because there was no machinery of that kind in those days. He never imagined that his daughter and, thus, he himself would be going in and out of this house someday.

My mother came from a relatively bourgeois family and then she married this son of a farmer. That was not a good match, of course, and she got no support from home. The two of them had to make a go of it alone.

My father only went to school for four years because he had
to help out on the farm at home. But he was talented and
acquired experience in various trades. Farmers had to struggle
just to survive; there was no room for individuality. My
father had twelve brothers and sisters, and five of them died of
tuberculosis. My grandmother was emaciated; the last two
or three children that she had were probably born prematurely
and didn't pull through. Their view of life, of survival, was
based on the farm. They cultivated fields to feed themselves.
They managed with very little, with practically nothing.

LAURA Your parents moved to Gossau after they got married.

URSULA We had a small house with my father's bicycle workshop
on the ground floor. There was nothing he couldn't do. He
taught himself everything: carpentry, mechanics—and later
he worked for a big company in Gossau that produced electric
machines for butchers. He earned a grand total of 190 francs
for two weeks. That was a pittance during the war. While
he was at the factory, my mother ran the workshop and took
in embroidery on the side. And she had two more children,
my brother Walter and my sister Brigitte. We would walk with
my mother from Gossau to Herisau in the evening in order
to deliver the goods that she had knitted or embroidered.
There was a factory that hired homeworkers to knit baby shoes,
caps, and things like that. Cutting out lace was also a cottage
industry. Lace would be embroidered on tulle and the tulle
between the trim and the embroidery had to be cut out with
small scissors. My mother had to earn extra money.

LAURA Did you have to help at home too?

URSULA Mostly I took care of my brother and sister when my
parents were away. I looked after them and took them along to
kindergarten. When my father developed lung trouble in
the foundry, the doctor told him he had to find another job.
And my jack-of-all-trades father said, "Okay then, I'll try going
into sales." That meant going from door to door in those days.
There were no shopping centers, at most only a general store

nearby or a butcher in the village. There was nothing else. My father started out peddling textiles. There was a company in Uzwil, Haag Montadon, that sold linens to farmers all over Switzerland, embroidered dowry linens and Sunday clothes with bustier and embroidery for the farmers. The farmers bought those items from peddlers because they couldn't leave their farms. So my father traveled all the time, through central Switzerland, to Appenzell, the Grisons, everywhere. But it didn't work out. He knew absolutely nothing about textiles! And when he had to measure suits for the farmers, they would end up too small or too long or too big. [Laughs]

MICHAELA What was it like for you, the children? Was your father strict? Did he make a lot of demands?

URSULA No, quite the opposite. He was loving and optimistic. Our mother was strict. She stayed in the background and managed everything. When my father was fired, the next business turned up: household appliances. His new employer was a company called Grossenbacher with branches all over Switzerland. They introduced new products from abroad, like washing machines. Our old washing machine was a copper boiler. We had nothing automatic or mechanical, and the hot water for the laundry had to be heated up on the stove. In the United States the first household appliances were being mass-produced, like the electric washing machine with a spiral and a drum, which could also heat up the water. My father went to trade fairs for Grossenbacher to find out about the latest developments. And then came the pressure cooker! We had a flex-seal cooker, that was before the Duromatic came on the market along with all the other devices that you can now get for steam cooking. That appealed to my father, and he started going from house to house again. My mother would join him. They packed the pressure cookers into the car in the morning, two, four, six liters, and so on, and then went from house to house, demonstrating how they worked and selling them. My mother knew how to cook, my father didn't. He couldn't

even peel potatoes. In fact, he couldn't do any housework at all.
But together, they were successful. Sometimes, they came home
with an empty car because they had sold all of the cookers.
My father was an ace salesman. He would start his sales talk
with the farmers in the stable, inquiring how things were going,
very friendly. Then he'd skillfully shift the conversation to
the wife and housework. "I have something that could make
life easier for your wife," and so on. Later he went on his own to
trade fairs in Germany to check out new inventions. There,
he found appliances like the baking lid. Some farmhouses didn't
have an oven, only the wood-burning tile stoves. He imported
the electric baking lid; it was a glass dome over a heating
element where you could watch the cake rising. That was a
top seller, of course! Later, he also sold small washing machines.
A huge novelty was the spin dryer because so far people only
had wringers. It was hard physical work for women to wring
out the laundry.

LAURA Were you using all of these appliances at home, too?

URSULA We always had the latest devices. Microwaves came from
the United States, and we were one of the first to have one at
home. Our income grew steadily, and we moved to a one-family
house in Uzwil in 1947. My father was always on the cutting
edge with film or photo cameras and, of course, always with
cars. He loved beautiful cars, in a village that had only five
to begin with. The doctor, the pharmacist, the mayor, and a
factory owner each had a car, and Mr. Fust had one.

LAURA You have often mentioned how careful your parents were
moneywise because there was not much left over for extras.

URSULA Yes, my mother, in particular, taught us how to make
a budget, to make money last through the end of the month.
Housekeeping money was scarce and sometimes there wasn't
any butter left at the end of the month. Extremely strict.
As children, we couldn't understand that. It was pretty hard.
Slowly, little by little, we prospered and were able to live
more comfortably.

Uzwil was an industrial town where well-to-do manufacturers lived, makers of textiles like Naef and Heer, and the machine factory Benninger and Bühler with thousands of employees. Bühler was run by men only, no women—obviously. Mostly, they were men who had had military training and preferably from Bern! For example, the head of personnel at Bühler was from Bern. Tradespeople like us didn't really count. We noticed it in school, too, where the children of Bühler employees were automatically assigned to the A class for the best students, the college preparatory class. We belonged to the majority, too, but we were never classed with the industrialists. They were a class of their own. That left its mark.

Schooling and Training: Family

URSULA After secondary school, I spent a year in French-speaking Switzerland. All of the girls had to do a year of domestic training and, if possible, in a different language area of Switzerland. England was out of the question—too far away and too expensive. I spent a year on Lake Geneva, working in a household and at the post office. In my free time, I would sew my own clothes. They must have stood out. I had an orange duffle coat tied with strings! And, of course, hairdos were also an issue. I was conscious of appearances, they were important to me.

LAURA You still have an affinity with the French language.

URSULA It was the second language that we learned in school. After my household year, when I was seventeen, I did an apprenticeship in textiles, working in the clothing and fabrics department at the Globus department store in St. Gallen. If you go into that field nowadays, they call you a textile merchandiser. Globus was the number one, *the* department store for anything and everything fashionable. The branches used to be able to do their own buying. I traveled with the textile buyer and we went to northern Italy to buy fabrics. We planned fashion shows and window displays, and I was involved in everything.

Ursula, 1968

Albert and Ursula Hauser with her brother Walter and mother Hedwig Fust, ca. 1960

Ursula in the Bernese Alps, 1969

Ursula and Albert Hauser, 1959

Hedwig Fust, Ursula and Albert Hauser, ca. 1960

My dream job was to be a designer of window displays or textiles. But that wasn't an option. At home, I was told to do something intelligent, something that I could apply in real life—typing, telephone operator, or customer contact. Later I went to Zurich, to the headquarters of Globus. I was nineteen when I got engaged and in 1961, when I was twenty-two, I married my first love.

LAURA Which was customary at the time . . .

URSULA Yes, it was. If you wanted to leave home, you had to get married because you couldn't just live with somebody. Albert and I saved money like mad. As the son of a tradesman, a baker, he had to help in the family business. With the money we saved, we built our first little home. For the wedding. Actually, Albert wanted to become a car mechanic and attend the Auto-technikum in Biel, which was specialized in automobile technology. All of his German relatives worked for BMW. But our workshop at home was becoming too much for my father, and shortly before Albert started studying, my father said to me, "Your new friend is a talented mechanic, he would be good to have around. Ask him if he's interested in working here." Albert went to a trade fair with him and they hit it off; they worked very well together. So in 1958, they founded the Fust Company in Oberbüren. Albert was the first employee and then others came, more and more. They built up the business. Later my brother also joined the business.

In retrospect, it was a golden time. If you were willing to work hard, had a little bit of know-how and could make a relatively small investment, you were able to prosper. The 1960s and 1970s were super. Albert was actually self-taught; it was only later that he got an education. He was a born manager. I also worked half days. My first daughter, Manuela, was born in 1963.

I used to take her along to work. It's a standard feature of our companies to accommodate women when they have a baby. I actually did everything: debits, credits, advertising, personnel. We opened one branch after the other, and I was also in charge

Miele advertisement, ca. 1959

Bühler building in Uzwil, ca. 1962

Fust delivery vans in Uzwil, ca. 1965

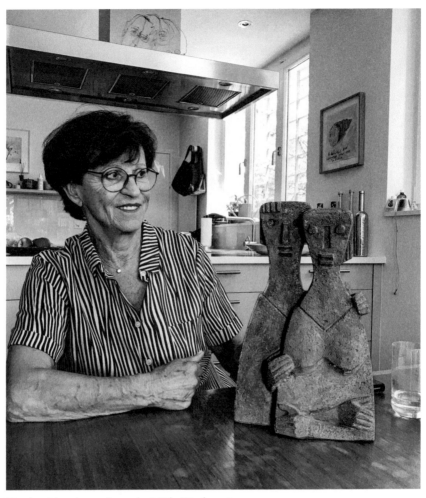

Ursula with a clay sculpture by Mädy Zünd, 2018

of the interiors and buying the furnishings. Wages were not paid electronically but personally, in an envelope. And we did something special at Christmas; we made Santa Claus bags that we sewed ourselves and filled them with goodies and the employee's bonus.

MICHAELA You started out in textiles and soon acquired a feel for design and aesthetics, and then you also became involved in furnishing rooms and interior decoration. Design has always been a part of your life. But you haven't mentioned the word "art" so far. Did that come later?

URSULA Jewelry has always been a great love of mine. I never bought anything ready-made, but I have had a number of pieces made for me. One of our friends was a goldsmith who made a piece of jewelry for me out of a gemstone, and so I started collecting hand-crafted art, jewelry and bangles. I was always around creative people: goldsmiths, decorators, architects, builders, designers, musicians, too, and, naturally, artists.

Art and Architecture

LAURA Do you remember the first work of art that you bought?

URSULA My first work of art was a fired clay figure by Meinrad Zünd. I was still in training and paid two months' wages for it. The sculpture shows two people, negative and positive. When you fold them together, they become a couple, a couple in harmony. Mädy Zünd is an artist from the Rhine Valley. The sculpture cost 800 francs! But I wanted to have it. I liked it and it meant something to me. I was very interested in the idea of abstraction. I wasn't too fond of explicitly figurative work. Given the stylized form, you can tell that the artist also made sacred art for altars and churches.

MICHAELA Which encounters were important to you and your husband in the early 1960s? What influenced your taste?

URSULA Traveling, for one thing. We often took trips to the north, to Scandinavia, Denmark, and Sweden. We did quite a lot. We traveled south as well, to Naples and Amalfi. Simply tracking

Ursula, Brussels, ca. 1961

Capri, 1965

Copenhagen, 1964

down architecture, churches, architectural monuments, and also looking into textile and design. We also visited the Bauhaus buildings in Dessau.

MICHAELA Did you go to museums?

URSULA Yes, but none for contemporary art. We knew nothing about it, we were leery of it. I thought, I don't understand it, so let's not go. What my husband and I really loved was architecture. We soon started putting up buildings ourselves, first apartment buildings and then larger structures and finally entire developments. I always worked on the planning, design, and choice of materials. We had already planned and built our own house in Uzwil back in 1961.

LAURA Which was extremely modern in those days, a bungalow.

URSULA We had a local carpenter make modern Danish furniture for us and I knotted colorful carpets, Finnish style. It's a pity I don't have them anymore; they would be all the rage again. My husband really enjoyed construction. For him, that was art— fair-faced concrete or beautiful wood. He was always trying to find special solutions and not just build something to live in.

LAURA You often mention the Bauhaus, in our conversation as well. How did you come across it?

URSULA There were journals about architecture and design. For example, *Du*. And documentary films, which have always appealed to me. And the ETH architect Fridolin Schmid was a friend of ours. He built most of our buildings for us and gave us a great deal of insight into architecture. He built from the inside out rather than the more common way of building from the outside in. He would visit his clients at home and ask them how they live, how many children they have, how they operate as a family, do they take baths or showers, and how often? There weren't so many bathrooms in those days; a five-room apartment had only one bathroom for the whole family. Schmid sharpened our awareness of form and material. We built a penthouse with a pool, the first home in the region that had a pool and greenery on the roof. It was all built of fair-faced block work and fair-faced concrete, very modern and timeless.

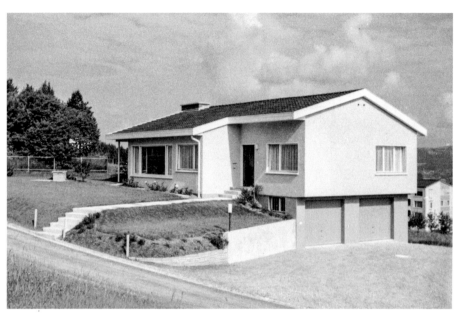

The Hauser family's bungalow, Uzwil, 1961

Ursula and Albert Hauser, 1972

Tilla Theus, 1993

Producing fair-faced concrete and also stucco is very challenging. The stucco on my house contains gravel, in the Bauhaus tradition. The craftsman was extremely competent, not just a semi-skilled worker. I always paid a lot of attention to materials and regional details. If you have an older building, you have to take the structure into account, emphasize it, and restore as much as you can.

MICHAELA You have become extremely savvy about architecture. Are there any projects that you would deal with differently today?

URSULA Yes! I wouldn't build on green meadows anymore. I certainly wouldn't do that anymore. Switzerland is so small, and we are destroying nature. There are a lot of Bauhaus buildings in Zurich, absolutely beautiful apartment buildings that would only need to be restored. Instead, they are ruined with synthetic materials and everything that has stood the test of time is destroyed.

LAURA Do you regret not having been able to go to university?

URSULA Yes. In retrospect, I would love to have become an architect. That would would have been my dream.

LAURA Architect or interior designer?

URSULA No, architecture in general. I am very close to the architect Tilla Theus. I've known her for a long time. And her work, like the conversion of Hotel Widder in Zurich, has always interested me a great deal. She restored the Jelmoli building, uncovering the original architecture. Actually, it originally consisted of three buildings around a courtyard that was just used as a storage space. Tilla integrated it into the department store. Her renovations are truly impressive.

LAURA Tilla is of your generation and has an exceptional position. Were you fascinated by the fact that she also managed to succeed in a man's world by being a little headstrong?

URSULA Exactly. But success came relatively late. She had to produce quality and it took years for others to be convinced. I've always taken note of how women manage to carve a place for themselves, whether they are doctors, teachers, or designers, like Coco Chanel, for example. I've always admired women who can assert themselves.

Ein Blick in die neue Galerie «Arte Nuova»; rechts die Galeristin Ursula Hauser (Bilder: Pius Walliser)

«Arte Nuova» – Eine neue Galerie in Flawil

«Nicht bloss Bilder aufhängen»

pd./Red. In den Kellerräumen der alten Fabrik Rohner an der Riederstrasse 21 in Flawil wird am kommenden Wochenende eine neue Galerie eröffnet. Die Galerie ist mit minimalen Mitteln durch den Architekten Adolph Blumenthal für die Galeristin Ursula Hauser und die Künstler, mit denen sie arbeitet, geplant und umgebaut worden.

Für die Kunstliebhaberin Ursula Hauser geht damit der langjährige Wunsch in Erfüllung: Einen Treffpunkt für die Region zu schaffen; ein Treffpunkt, wo Kunst optimal präsentiert werden kann. Für kommenden Samstag und Sonntag ist von 11 bis 16 Uhr ein Galerie-Apéro vorgesehen.

Lust zum Verweilen

Die Galeristin will nicht nur mit Hammer und Nägeln eine Reihe Bilder aufhängen: Ursula Hauser: «Eine Ausstellung muss in die Räume hineinkonzipiert werden und Lust zum Verweilen ausstrahlen.» Für die Galeristin ist es die erste Ausstellung, die sie «hängt». Durch die langjährige Bekanntschaft mit namhaften Galeristen jedoch weiss sie, dass eine erfolgreiche Ausstellung

bereits mit dem ersten Gespräch mit dem Künstler beginnt. «Die Auswahl und der Umgang mit Künstlern braucht viel Einführungsvermögen», sagt die Galeristin, was einen grossen Zeitaufwand erfordere: «Um so schöner dann, wenn man vielen Besuchern neue Kontakte vermittelt werden». Die Kunstliebhaberin weiter: «Der Besucher kommt in die Galerie, verfolgt zuerst den Gesamteindruck und erst dann, wenn dieser stimmt, ist er bereit, sich ein einzelnes Kunstwerk anzuschauen. Stimmt der erste Eindruck nicht, fehlt diese Bereitschaft.» Für sehr wichtig erachtet Ursula Hauser Querverbindungen zu anderen Galerien im In- und Ausland. So könnten in der Region auch weniger bekannte und junge Künstler dem Besucher nähergebracht werden.

Erste Ausstellung: Hermann Hofmann

Die erste Ausstellung ermöglicht dem in Unterengstringen wohnhaften Maler Hermann Hofmann, Jahrgang 1920, in der Ostschweiz bekannter zu werden. Seine Werke werden seit 1947 an diversen Kunstausstellungen in der

Schweiz und auch im Ausland gezeigt. Hermann Hofmann ist ein Vollblutmaler. Als Autodidakt, der sein Handwerk versteht, ist er seine eigenen Wege gegangen. Er ist künstlerisch schwer einzuordnen. Seine Anfänge stehen im Zeichen der figurativen Malerei. Heute hat sich der Künstler ganz der abstrakten Kunst zugewandt. Seine Malkunst strömt trotzdem Stille und Harmonie aus, da er für das Durchspielen einer Farbe oder verwandter Farben oft Erdtöne bevorzugt.

Nicht als Gegensatz, sondern als harmonische Ergänzung präsentieren sich die Skulpturen von Jacqueline Urbach aus Zürich. Alle ihre Werke wirken wie edler Schmuck. Jacqueline Urbach verbrachte über zwei Jahrzehnte in den USA, wo sie ihre Fähigkeit von Grund auf erwarb. Auch ihre Werke erfreuen sich eines grossen Freundeskreises.

Die Ausstellung dauert vom 19. September bis 24. Oktober; Öffnungszeiten: Mittwoch und Freitag 16 bis 20 Uhr, Samstag 10 bis 16 Uhr oder nach telefonischer Vereinbarung, Telefon Arte Nuova, 071 / 83 55 45, Privat 073 / 51 68 63.

Ostschweiz 17. 9. 87

Nächste Ausstellungen
Gérard Renouf
Hermann Hofmann

Ständige Auswahl von
Annette Cladt
Carl Liner
Hermann Hofmann
Hans Folk
Robert Zielasco
Jürgen Görg
Gisela Krause
Veronika Bischoff
Frederick Bunsen
Dea Murk
Ernst Tinner
Roman Casanova
Josef Ebnöther
Pli Ebnöther
Rolf Ziegler
Jorgen Waring

arte nuova
GALERIE

Galerie arte nuova
Riederstrasse 21, 9230 Flawil
Tel. 071 835545

Ursula Hauser

Newspaper article about the Galerie
Arte Nuova, 1987

Invitation card, 1989

arte nuova
GALERIE

Galerie arte nuova
Riederstrasse 21, 9230 Flawil
Tel. 071 83 55 45

Ursula Hauser

Beat Bösiger, Bildhauer

Während der Ausstellung von Hermann Hofmann sind neue Arbeiten seines jungen Freundes Beat Bösiger zu sehen.

Invitation card, 1990

Regional Art and Galerie Arte Nuova

MICHAELA You started getting involved in art in the 1960s. Did that go hand-in-hand with your building activity and your interest in architecture?

URSULA We started out buying works by local artists like Ernst Tinner, Josef Ebnöther, Rolf Hauenstein, Carl Linner, and Peter Feder. They all deserve respect but, unfortunately, never acquired a reputation beyond their own home territory. We also bought a few works by Hans Falk.

MICHAELA Did you know the artists personally?

URSULA Yes, they always came and went in our house. And it's still that way with our artists. We would meet on weekends or were invited to birthdays. To me, support means acquiring something an artist has made. In the mid-1980s, I set up my own showrooms in the abandoned Rohner Textile factory in Flawil: Galerie Arte Nuova. Actually, it wasn't a gallery; I just wanted to give local artists a platform. We had acquired the old factory with the intention of converting it into apartment buildings and lofts. We had refurbished some of the rooms, one or two white cubes, in which artists could exhibit their work: Hans Falk, Bruno Gasser, Rolf Hauenstein, Ernst Tinner, Gisela Krause.

LAURA Did you print and send out invitations? And produce catalogs?

URSULA Yes, of course. My first art book was about Hermann Hofmann, a student of Max Gubler. People still ask me whether I have any Hofmann landscapes.

MICHAELA Was that also a way of supporting your artist friends— by giving them the opportunity to have an exhibition?

URSULA Exactly. The gallery was open Wednesday afternoons and Saturdays. Manuela was in teachers college at the time and didn't have school on those days. We would go to art fairs, for instance, to ARCOmadrid. If something appealed to me, I would get in touch with the artist. It wasn't about doing business, but primarily about giving artists from southern Germany and Switzerland a platform.

LAURA Did you sell work in the gallery?

URSULA Yes, certainly, and Manuela did too. I never thought we would sell anything, but our sales were really good, and we established a few regional collectors. We also rented out rooms for weddings and things like that. There was no comparable modern space. Later, my sister took over the gallery.

Work and Family

MICHAELA You mentioned the architect Tilla Theus, who succeeded in establishing herself in architecture, in a man's world. What about your own biography: your daughter Manuela was born in 1963, and a year later your son Urs, and then in 1968, your youngest daughter, Sandra. In addition to doing the housework and looking after three children, you worked in the family business. What was your daily life like juggling your children and your professional work?

URSULA My family, my children, naturally had the highest priority. They were my most important job and I wanted to get it right. I used to cook with them and do other projects with them, making things. We would also make a fire in the woods or go fishing in the river. We did a lot of things together. And when they were in school, I was always there for them—on standby.
Being at home gave me time to develop our rental-purchasing business. Nowadays it's called leasing or installment buying. We made it possible for customers to pay for a washing machine in installments. We would purchase the washing machine from the company.

MICHAELA How did you come up with that idea?

URSULA My husband and I worked it out. Cars were available on installment and we thought we could apply that model to our business as well. Refrigerators were already as expensive as they are today, which could mean up to three months' wages. Everything has become much cheaper now.

Ursula and her daughter Manuela in Venice, 1997

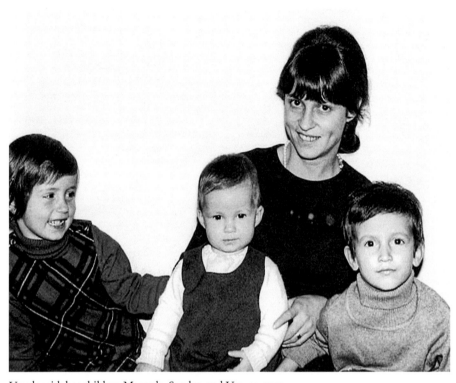

Ursula with her children Manuela, Sandra, and Urs, ca. 1970

LAURA Your husband died in 1973 after a short illness, and you were left alone with three children—ten, nine, and five years old.

URSULA I followed my brother's advice and took over my husband's job in the company. A neighbor of mine took Sandra to kindergarten. I managed the rest myself with the help of my children. We cooked together in the evening, simple meals and food they liked. One of them set the table, the other washed the dishes. We were a team. The children had to pitch in. Manuela would look after her siblings. She even did the cooking when I had to leave on business, for instance, to open a new branch. By the time she was twelve, she was able to manage the household herself for a couple of days. Sandra was only seven or eight years old and Manuela was actually her mom. She took entire responsibility. Urs was not much help in that respect. He was not particularly talented when it came to housework. But he did start cooking later and has now become a wonderful cook. They are all independent and extremely competent. And that was my goal.

LAURA Did your mother back you up during that time?

URSULA She was on the road a lot. Automatic appliances had come onto the market and women had to be introduced to them. That was what my mother did. She liked driving and traveling. They sent her to the older women to demonstrate an automatic washing machine or how a new range works. Manuela later became a home economics teacher. That comes from my mother in a way. She always managed to make something beautiful out of old things, for example, a tablecloth. She also took very good care of my children. She didn't just babysit; she really had something to offer. She made things with them, sewed, cooked, and taught them a great deal.

I worked for the Fust company every day for almost twenty years. At the very beginning with the debtors and later the creditors. In the end, I was able to delegate more and more, and they became separate departments. We had a good income, a house of our own, a bungalow, and one, two cars in front of the garage. That was a pretty sure sign of high-end luxury.

And the fruit of our own hard work. My father had the motto: "Buy yourself something when you have enough money to afford it." When I bought my first car he said, "Instead of buying one for the 1,200 francs you've saved up, buy a car for 600 francs. That way you'll have some savings left over just in case. You never know."

LAURA Things weren't always so rosy for your company. For example, when the bank called on its loan.

URSULA Yes. That was in 1972, during the oil crisis. It was an important learning process. The banks had obliged us to pay back a loan within three months. Some of our employees showed solidarity and said they would help by lending us their savings. Without them, we would have gone bankrupt! Naturally, we paid good interest on those loans. It showed us that we had to stand on our own two legs. I would never take out a loan to buy art. Never. Nothing. I learned my lesson. I just use banks for transactions—that's all.

LAURA The solidarity you experienced made a great impact. You often mention the importance of treating your employees well. The fact that it was a family undertaking also played an important role.

URSULA It certainly did. When somebody was in trouble, you helped. And the other way around, too. It's still that way with our older employees. It's similar in the gallery even though it's not as pronounced as it used to be because we have now gone global. If we had only one location, people would run into each other on a daily basis and would know how everybody was doing. But even so, you still sense the close contact and mutual appreciation. That's a long-term thing.

Fust warehouses in Oberbüren, ca. 1970

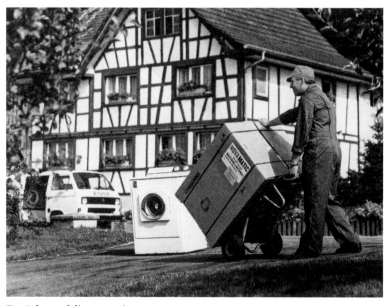

Fust's home delivery service, 1980

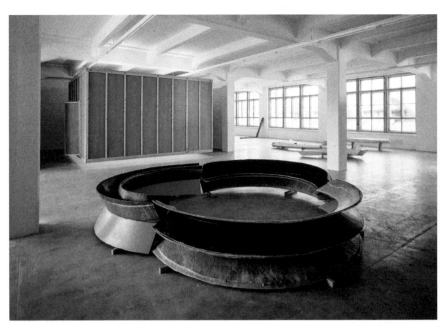

Works by Bruce Nauman, exhibition view, Hallen für Neue Kunst, Schaffhausen, 1989

Dan Graham, *Two Joined Cubes (Dedicated to Roy Lichtenstein)*, 1996–97, exhibition view, *Kunstausstellung Holderbank*, 1998

Seminal Encounters in Eastern Switzerland

MICHAELA At the end of the 1980s, you met your future business
partner, Iwan Wirth.

URSULA Iwan ran his first gallery in Oberuzwil from 1986 to 1989.
We were practically competitors! We used to visit each other.
He was about sixteen or seventeen and still studying for his
baccalaureate. Then he rented a five-room apartment in an
art nouveau building and presented classical exhibitions there.
He showed artists like Bruno Gasser from Basel, as well as
Daniel Spoerri and Alois Carigiet—all of them from Switzerland.
By that time, my children had completed their education, they
had flown the coop, and I was able to realign my life. I had
worked at Fust for almost twenty years and knew I couldn't live
out my life there. So I left. I was free to travel again—at last!
Iwan and I often met in the gallery or in a museum or at
the Hallen für Neue Kunst in Schaffhausen. He showed and
explained so much to me. He was self-taught, but always
extremely well-informed.
He also had a good friend at the Kantonsschule St. Gallen,
Hans Ulrich Obrist. An absolute whiz and incredibly focused.
Hans Ulrich put up a kitchen exhibition in St. Gallen, where
I bought a work by Richard Wentworth. Hans Ulrich was never
an art dealer; he is and has always been an exhibition maker.
Iwan still sees a lot of him. For example, they made a small
publication with Paul Armand Gette, which I bought from
Hans Ulrich. I had to climb over stacks of books in his living
room. He didn't really have a place to live; it was more like
a warehouse of books with a bathroom and a kitchen! They
used to meet at lunch at the Erkergalerie and were always
totally up-to-date on what was going on. Obrist gave us a lot
of tips and drew our attention to artists like Roman Signer and
Gerhard Richter, with whom he had made the slim postcard
book in St. Moritz.

Richard Wentworth, *World Soup,* 1991, exhibition view, *Küchenausstellung,*
curated by Hans Ulrich Obrist, Schwalbenstrasse, St. Gallen, 1991

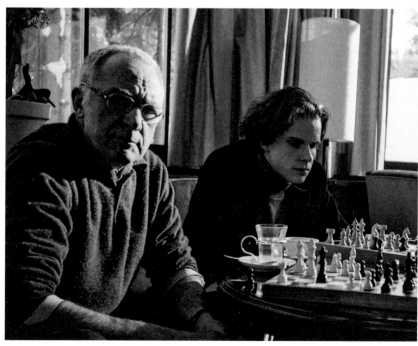

Hans Ulrich Obrist with Gerhard Richter in Sils Maria, 1992

Iwan told me which journals I should subscribe to: *Du, Hoch-parterre,* and *Parkett,* of course, and I've subscribed to *Art* ever since. Later, *Artforum* joined the crowd. Iwan is a bibliophile, that's why he also supports the gallery's publishing department, for which you are responsible, Michaela. Not many galleries do that, although there are many that try to follow suit.

MICHAELA You are describing a key aspect of your gallery work, namely, sharing art, making it accessible.

URSULA Iwan kept giving me books, often biographies, because I like them: Mata Hari or Peggy Guggenheim. Their stories gave me the strength to be more daring. Just do it. It's never too late. I even briefly entertained the idea of attending courses in adult education. But then I decided that I didn't want to start by studying the Old Masters.

Iwan and I joined forces at the end of the 1980s. The timing wasn't exactly ideal. The stock market crashed in 1987, Black Monday. The entire art market was completely unhinged. The crash had cut everything in half: the real estate market, shares, the stock market. Obviously, the art market was no exception. I remember walking through London with Iwan, along Old Bond Street and New Bond Street. Every other business was boarded up! Same thing in Los Angeles and other places. I thought the economy would never recover! Some-times, Iwan wishes he had persuaded me to go into real estate in London.

At the time, Iwan was working with DOBE Gallery, run by Ralph J. Dosch and his partner Jürgen Becher from the Grisons. They belonged to another generation. Their focus was classical modernism and they dealt primarily in Spanish artists, Tàpies, Chillida, and also Picasso. The artists represented in his gallery, and mine as well, didn't provide much of an income, just enough to cover the cost of the exhibitions. That was it. And it's still the same with young artists today. You have to establish them first. International art was an entirely new field for me. I had basi-cally only kept abreast of regional art and art in Switzerland as

a whole. Now I had a new interest, and my horizons opened up. Iwan was just the right person for that. He was a dynamic spirit, full of visions and enthusiasm. Initially, my support was mostly financial. He had the craziest projects, reaching for the stars, and someone had to pull him back down to earth somehow. [Laughs]

[The telephone rings. It is Iwan Wirth.]

LAURA Iwan wasn't even twenty yet. Didn't your family—your children, your brother, your parents—wonder, what in heaven's name are those two people doing?

URSULA My family just hoped it would work out! It could've gone wrong, of course. Relatively large sums of money were involved. We had invested in two or three high-priced works.

Zurich: A Gallery Is Established

URSULA After his baccalaureate, Iwan wanted to study law in Zurich. There he found a spacious art nouveau apartment on Sonneggstrasse near the University. It had room enough for exhibitions. He always had a flair for quality, in clothing, in art, in everything! Everything had to be the best of the best. And when I asked him about flying first class, he would reply, "Our clients don't sit in economy class." And wouldn't you know, he really did meet a future collector in first class in what was then still Swissair! [Laughs]
Actually, I also have a flair for quality. That doesn't mean it has to be expensive. I sewed my own clothes, but my clothing was exclusive and unique! I didn't need an expensive label. A lot of young people around us were already so aimless. Iwan was the exception. I was fascinated by his potential. And I wanted to diversify. I had always had good dividends and a handsome salary as a shareholder and employee in the former family business. But it was just paper! No substance. It didn't do much for me. I don't understand technology, and I'm not very good at marketing either. Art is enriching.

Iwan Wirth and Ursula at Sonneggstrasse, Zurich, 1993 (in background:
Eduardo Chillida, *Oxido 78* (*Oxide 78*), 1983)

Andi Illien and Iwan Wirth, Zurich, 1993

GALERIE HAUSER & WIRTH AG
SONNEGGSTRASSE 84, CH-8006 ZÜRICH, TELEFON 01/364 01 41, TELEFAX 01/364 01 44

Handel mit Kunst des 20. Jahrhunderts. Impressionismus, Klassische Moderne, Bauhaus,
Deutscher Expressionismus, Abstrakter Expressionismus, Pop-Art, ausgewählte zeitgenössische Kunst.
Besichtigung und Beratung auf Vereinbarung.

SAMMLUNG HAUSER & WIRTH
HARDTURMSTRASSE 127, CH-8005 ZÜRICH, TELEFON 01/273 50 70, TELEFAX 01/273 50 72

Ausstellungsraum der Sammlung Hauser & Wirth. Museale Präsentationen von Klassischer Moderne
bis zur Gegenwart. Schwerpunkt-Ausstellungen von Künstlern und Werken aus den Beständen der Sammlung.
Verlagstätigkeit. Während der Ausstellungen täglich geöffnet.

Brochure, 1992

MICHAELA You sensed that art has something to offer and it appealed to you. And then you came across someone who showed you the ropes. In addition, you are apparently willing to take a risk, to try something out and see what comes of it.

URSULA Only to a certain extent, not unlimited risk. I don't do that at all. I just wanted to diversify, the way I would advise anyone who wants to invest money: diversification in real estate, fixed assets, and a little surplus to play with. You could tell that there were collectors around and that assets were being shifted to alternative investments. That is always the crucial point; you sense that in dealing with one-offs and exclusive items. It's a long-term approach.

MICHAELA Did you see yourself more as an investor? Or were there works you would have liked to keep for yourself?

URSULA I was supporting a few artists at the time, but I didn't just want to lend them money. I preferred to buy works from them. It had to be fair. I never lend money. I have always said I'm not a bank. I don't understand banking, I leave that up to the professionals.

MICHAELA You and Iwan established your gallery in 1992. It was initially called the Hauser & Wirth Collection. How did you divide your roles as partners in the gallery?

URSULA We talked a lot about what there was to do, who we should get to know, what was on the market, which exhibitions we should go to. We traveled to New York and Los Angeles, to Japan, Korea, and Russia. Then Iwan suggested opening a gallery together. At his age, he had nothing to show, no references, no bank. I provided the financial support but always with the proviso that revenue comes in and doesn't just go out. He explained his plans and intentions in great detail. I have a realistic business sense and was able to envision how much it would cost and what could go wrong. We decided on a program together. But Iwan was the doer. I could never have run a gallery!

Iwan Wirth and Bruno Weber, Zurich, 1997 (in background: Stefan Banz, *You Can Spend Your Time Alone,* 1996)

St. Petersburg, 1994

Tokyo, 1993 (photo by Ursula, partial view of Iwan Wirth)

State Hermitage Museum's art storage, St. Petersburg, 1994

We had no staff, only a secretary on an hourly basis, an older woman.

We hired Iwan's friend Bruno Weber as our photographer and Manuela came in on Wednesdays and Saturdays to do administrative work. It wasn't her field, but she is very thorough, which was exactly what Iwan needed. He thought her English was poor, that she should take some time off to learn English, go to New York and enroll in a language course, ideally at Columbia University. So she did. He visited her there and they've been a couple ever since. The rest is history.

Artists, Galleries, Institutions, and Collectors: The Swiss Art Scene

MICHAELA You mentioned the importance of studio visits and how they motivated your travels. Were you visiting more as an art dealer or as a collector?

URSULA More as a collector, I'd say. The gallery acquired a life of its own, it expanded, we had more and more employees and I was no longer operatively involved. I was more responsible for the financial aspect. Banks weren't loaning money, only if somebody was successful, and galleries were at the bottom of the list. So then it was my turn.

MICHAELA Even so, you always say we did so and so when you talk about the gallery work.

URSULA Yes, of course. I am always informed about everything the gallery does but I have never been operatively involved, not even in an advisory capacity. If I had been, the gallery probably wouldn't be where it is today. Our teamwork functioned like this: I was the mature, more thoughtful part. And the young generation led the way. They had ambitious goals, sometimes too much so, and we would meet in the middle. That ensured a solid, realistic approach to doing business. I think that's where I came in.

MICHAELA What are your recollections of the art context in Switzerland in the late 1980s and 1990s?

URSULA It was incredibly exciting. An extremely important player was *Parkett*! We often met with Bice Curiger, Jacqueline Burckhardt, and Dieter von Graffenried. In 1994, to celebrate ten years of *Parkett,* we exhibited the sixty-one artists' editions so far created for the journal at our gallery on Hardturmstrasse. Later I donated my entire collection of *Parkett* editions to Kunsthaus Zürich. That was in 2004, and one of my first endowments.

The galleries in Zurich had exciting programs, the established ones, naturally, like Bruno Bischofberger, Thomas Ammann Fine Arts, Galerie Verna, Andi Illien, and Mai 36. If you were interested in younger artists, like I was, then Galerie Walcheturm was the place to go. Through Eva Presenhuber, we met Urs Fischer, Fischli & Weiss, Dieter Roth, Ugo Rondinone, and many others. Zurich was one big artist family!

We would meet all over the place, at the Kunsthaus previews but also at Kunsthalle Zürich, recently launched by Mendes Bürgi, with Hans Ulrich Obrist, Harald Szeemann, or my collecting friends Franz Wassmer and Theo Hotz. We also met Andi Stutz through Eva Presenhuber; he has become a good friend. We would often meet at his restaurant Seidenspinner in Zurich; the interior was decorated by Ugo Rondinone.

Polaroids from the guestbook for Dieter Roth's installation
Bar 2 (with Björn Roth), Zurich, 1997

Franklin Street, New York, 1993

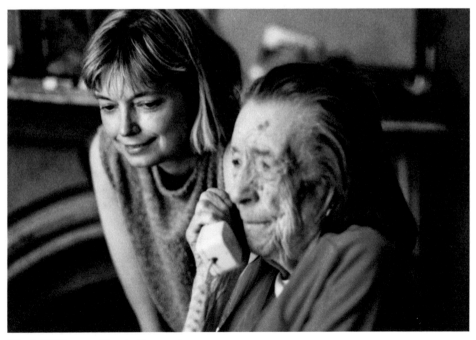

Wendy Williams and Louise Bourgeois, 2002

Off to New York!

MICHAELA The United States was already part of your life in the early 1990s. You traveled a great deal, to New York, Chicago, Los Angeles, and in 1993, you bought an apartment in New York, on Franklin Street.

URSULA It was both an apartment and a showroom. We didn't have a gallery. We visited galleries in New York, made contacts, with Colin de Land, Pat Hearn, Marian Goodman, Paula Cooper, and Leo Castelli. Franklin Street wasn't far from SoHo and we would take off every morning, going in and out of galleries. In the process, we naturally met artists who lived nearby and had studios there, like Donald Judd.

We had a few contacts from the scene in Cologne: Rudolf Zwirner, Galerie Neuendorf, Kaspar König, and his brother, Walther König, the publisher and bookseller. Through our contacts in Cologne, we met David Zwirner, who was then working for Brooke Alexander in New York. David was actually a musician and never intended to become an art dealer. And then suddenly he was roped in. He opened a gallery in his SoHo loft with Franz West and Jason Rhoades.

Iwan always knew where to go; he was incredibly goal oriented and still is. He'd say, "Today we do SoHo, then we go to 57th Street, to Marlborough, Pace, and all the rest."

The first time I saw Louise Bourgeois's *Personages* (1947–53) was at Robert Miller Gallery. It knocked me over. Robert Miller also represented Eva Hesse. Louise Bourgeois's longtime studio assistant, Wendy Williams, was then working there, too. Iwan introduced himself: "I am Iwan Wirth, we're from Switzerland," and so on! [Laughs]

Pat Hearn was a key figure among the galleries. A beautiful woman, she had even been one of Andy Warhol's models, and she was utterly taken with Iwan. She always kept him informed: "Listen, I've got this or that." She had already worked for Mary Heilmann. And, of course, it was Pat who introduced us to Colin de Land, her husband.

Manuela Wirth at her birthday party in New York, with Pat Hearn and Mary Heilmann, 1997 61

At some point, Pat had her fill of SoHo. It had become too crowded, too expensive, and all these chic boutiques started moving in, pushing up the rents. So she relocated to Chelsea; she was one of the first. Pat Hearn was one of those people you would contact when you went to New York. She's the one who founded the now legendary Armory Show with Colin and two other partners. Their first venue was the Gramercy Park Hotel, and it was originally called the Gramercy International Art Fair. We were part of it from the beginning.

That was also when I acquired *Legs* (1989), the very first work in what was to become my Bourgeois collection! I had seen the installation at the Venice Biennale in 1993, where Louise Bourgeois had been selected to represent the United States. The piece was in the back of my mind, something that I would buy if I could. I knew that there were three editions, and, to my delight, Pat Hearn had one of them.

Mirror of Humanity

Mary Heilmann

URSULA I also discovered works by Mary Heilmann at Pat Hearn's gallery. The first things of hers that I acquired were *Little 9 × 9* (1973), *Chinatown* (1976), and *The First Vent* (1972). And I've always wanted to know about the person behind the work. I wanted to meet the artist, that was one of my conditions. And so we went to Mary's studio.

LAURA Where did you first meet her?

URSULA Mary had a studio in a building with a view of the Hudson River. She had screened off part of the studio with some curtains because she also lived there. We have since become close friends. At large events, we try to be together as much as possible. We are the same age, only a year apart, but even though we are of the same generation, she is very young artistically. She has a lot of young friends not only in the fine arts but in music as well. She usually brings somebody along from some literary or music scene, people who are mostly a generation younger, if not more.

Ursula and Mary Heilmann in the artist's studio, 2009

As soon as it's mine, I want to live with it. I want to study it, appreciate it. Some works soon disappear again, but many stay on my walls forever.

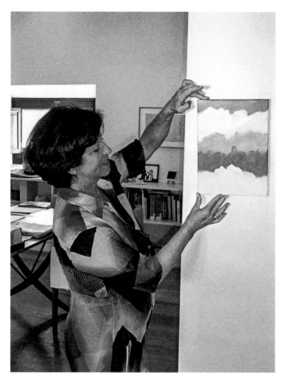

Ursula with Mary Heilmann's work *Montauk Surf
(for Ursula)*, 2009

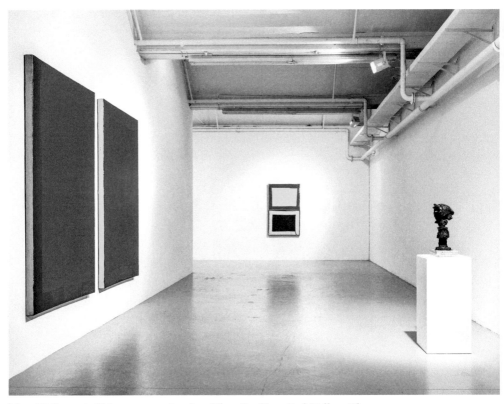

Mary Heilmann's *Chinatown*, 1976, and *1st Three For Two: Red, Yellow, Blue*, 1975, and Paul McCarthy's *KKKKK*, 2009

Mary's art is so young, too, and she certainly doesn't act her age. To me, she really belongs to the young generation!

I have always wondered how and where she gets her ideas and where she gets her energy from. She was inspired by minimal art, but she practices it in her own distinctive way and mostly does paintings. She also makes objects and reliefs but painting is actually her medium.

She is so young and dynamic, like a girl, and that's what her wonderfully colorful paintings are like too, along with their titles.

In conversations with her, I keep trying to figure out how she ticks. She is extremely hard on herself. She doesn't drink, doesn't smoke, and yet she's out and about. That's not easy. There is a special lightness to her work and, at the same time, when you study her subject matter and titles, you realize what great depth it has.

She was intensely involved in the 1968 scene. She comes from San Francisco and was closely associated with the surfing scene and musicians in California. And then she moved to New York, where she had better opportunities. In California, it's more about studios, art schools and universities like Berkeley, and in New York, it's more about dealers, galleries, the big museums. Museums are probably also one of the reasons why Mary ended up in New York—even though she is strongly attached to nature. She now lives mainly in the country and has a studio on Long Island. She is always one for surprises, coming up with new works, doing ceramics, making beautiful dishes and other utilitarian objects like chairs and tables. And she takes inspiration from other artists, like Franz West. Franz and Mary were very fond of each other.

LAURA You just mentioned the first work that you bought by Louise Bourgeois. What was it about Legs that exerted such an appeal?

URSULA The material. The form. It was abstract. Two legs simply suspended in the air. Not standing on the floor. The whole thing, the instability. And the materials she used. The legs are rubber and when you touch them, they vibrate and wobble. It's the combination of material and form. When I have my mind set on something, there's no deviating, no right and no left. I'm so focused, it's like being in a tunnel. I want that, and nothing else. Just straight ahead.

And so we managed to visit Louise's studio. One of our first visits was in November 1993 in Brooklyn. Louise was still going over to her studio. Later we visited her at her studio at home.

LAURA Jerry Gorovoy clearly remembers how you and Iwan sat with Louise on her blue couch. She was eighty-two years old at the time.

URSULA When we made the appointment, she instantly told us that she only had half an hour. Jerry came to the door: she has quite a bit of work to do, so we have to do it this and that way. She was sitting on a high stool at her desk and talked like a waterfall. French and English. We were fascinated and could barely get a word in edgewise! I was able to speak French with her and she opened up a bit. But she was a bit crusty, like: "What are you here for? What do you want from me?" She never wanted to sell her works!

MICHAELA Did she show you any of her work?

URSULA More her projects, not necessarily the art. Later, when she stopped leaving the house, she made sculptures out of iron in the cellar. There she showed me what she was working on: cloth sculptures that she had just started. She put together scraps of fabric at her desk and said: "Look here, that's going to be a head." Her hands were old and wrinkled and still so nimble! She kept the wooden *Personages* in the cellar.

Louise Bourgeois: Recent Work, American Pavilion,
45th Venice Biennale, Italy, 1993

I've always wanted to know about the person behind the work. I wanted to meet the artist, that was one of my conditions.

Louise Bourgeois, *Passage Dangereux*, 1997

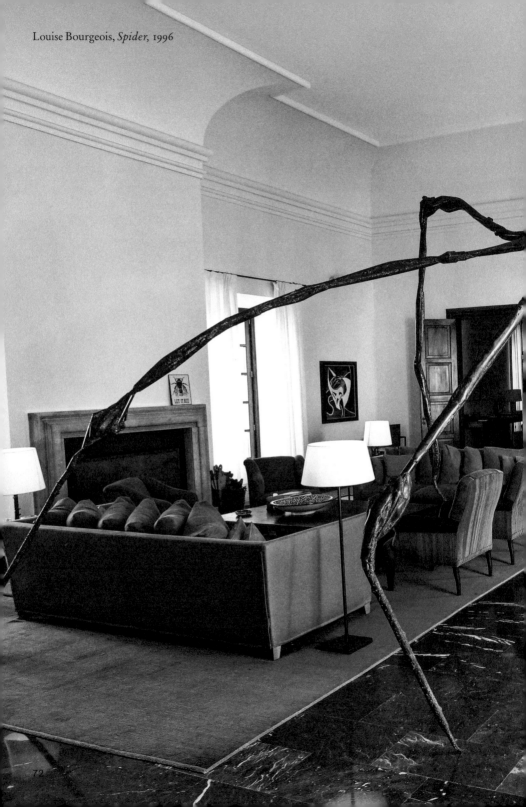

Louise Bourgeois, *Spider,* 1996

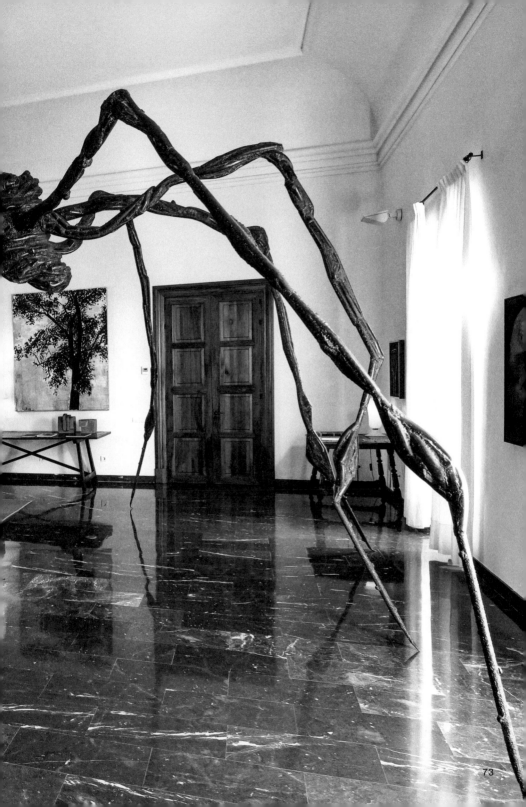

They're all in museums now. And there was a sewing machine, alongside new models and plasters for her various projects, including those she never made. That was Louise. It was incredibly impressive.

LAURA Did she want to know which works you were thinking of buying for your collection?

URSULA She would always say: "I have to keep going!" And then she showed me how intensely she was planning. Never looking back. She never dug up things from the past, except when they related to her parents or her origins or the tapestries. She showed me the tapestries that she used for *Passage Dangereux* (1997). They were extremely important to her. But she never talked about her childhood or her family. Actually, only about what she was planning to do. She bubbled with ideas. You could tell especially by her hands and her striking voice. Her body was gradually giving way and she was extremely fragile. But thoughts still kept gushing out. Her mind and hands were intact until the very end. She had a fascinating aura!

LAURA You have acquired some large installations by Bourgeois, like *Passage Dangereux*. And you now have one of the largest private collections of her works. Your fascination has not let up.

URSULA No. Obviously, after she died, nothing came from her hands anymore. To me, her hands were *the* instrument. When she was no longer able to work in marble and steel, she changed direction and started using everything she had at home, like her clothing—the way I use remnants. She created new sculptures with whatever she had around. Sometimes even beautiful works, white and pink plush, but curiously hard, like these fabric heads that are actually screaming.

LAURA The Bourgeois works that you have in your collection address existential issues: birth, death, being caught up in a situation from which there is no escape.

URSULA Yes, like a woman in a man's world, who has only herself to rely on. Women who support a family and have to survive—it doesn't occur to anyone that they might have personal feelings.

Louise Bourgeois, *The Good Mother (Topiary)*, 1999

Louise Bourgeois, *Maisons Fragiles*, 1978

You simply have to fight, it's a struggle, and you have no choice but to make something good, something better out of it. The war years, schooling, the children. Nowadays children are nurtured. Every evening I say to my grandchildren, "I love you, I like you, you're the best." Nobody ever said that to us, ever! We were always having to prove ourselves.

Louise Bourgeois's work is like a mirror of humanity. For people of my generation, it was impossible to let on that you were vulnerable. You would never reveal the reflections on your inner mirror. That was a sign of weakness and then you would have been lost. And that is exactly what Louise's work shows. Her art creates a space where that can be expressed.

MICHAELA What are the key highlights of your Bourgeois collection?

URSULA The spiders. Clearly the spiders. All of them, the big ones integrated into installations, the small cute ones squatting on the floor, and the spider drawings. Some of them are beautifully done, others less so. And then there are all the works based on memorabilia, processed by Louise in her own inimitable way. Viewers can't tell right away what she's getting at when she works these objets trouvés into a sculpture.

Then there's *Maisons Fragiles* (1978). An incredible work. The sculpture can't stand alone; it needs support. It's not only beautiful, it has an uncanny, symbolic presence. Look at Michaela, so tall. I bet she would wobble too, standing all alone on the floor! [Laughs]

MICHAELA [Laughs] We all wobble somehow.

URSULA Exactly, that's what I mean. And then there are the cells that you look at from outside. You see an abused, suffering girl who has somehow found sanctuary in there. You can't touch her.

LAURA And she can't get out.

URSULA She can't get out, but she has enough air because there's gauze in the back. Louise's drawings are very important to me, too. And I love the collages in which she processes her fabrics and notebooks. She had such an extraordinary imagination!

MICHAELA Beginning with Bourgeois, your collection traces a specific trajectory both in content and in form. Which artists did you collect in connection with that trajectory?

URSULA For instance, Berlinde De Bruyckere and Alina Szapocznikow, especially in terms of materials. Louise used not only stone, marble, paper, and fabric, but also polyester and rubber. And there are links to other artists like Heidi Bucher and Eva Hesse.

MICHAELA When did you realize your heart as a collector was pushing you in this direction, toward these women artists, and that the works you choose to collect clearly show a tendency to mirror your thoughts and feelings?

URSULA Vulnerability! I don't think I realized it. Talk about it? I never had the time. Think about myself? I always had to keep going, keep moving ahead.

Living with Art

Eva Hesse

URSULA I am extremely attached to most of what I've bought. And if you like something, you don't generally like giving it away. That applies to Eva Hesse's works. I live with them and have hung them in my house. For example, a portrait from 1960 that really gets under your skin. She was so young, in her early twenties, when she painted it. It's a work I can look at and study over and over again.

I became acquainted with Hesse's work through Robert Miller Gallery in New York. I was hopelessly fascinated; her biography really moved me and so did her artwork—obviously. Helen Charash told me a great deal about her sister. They were both little girls when they left Nazi Germany in 1938 on a Kindertransport to Holland. Only later were their parents able to flee. They joined them there and the family managed to escape to New York. I found that in itself incredibly touching. And then what came of it. Hesse was a born artist;

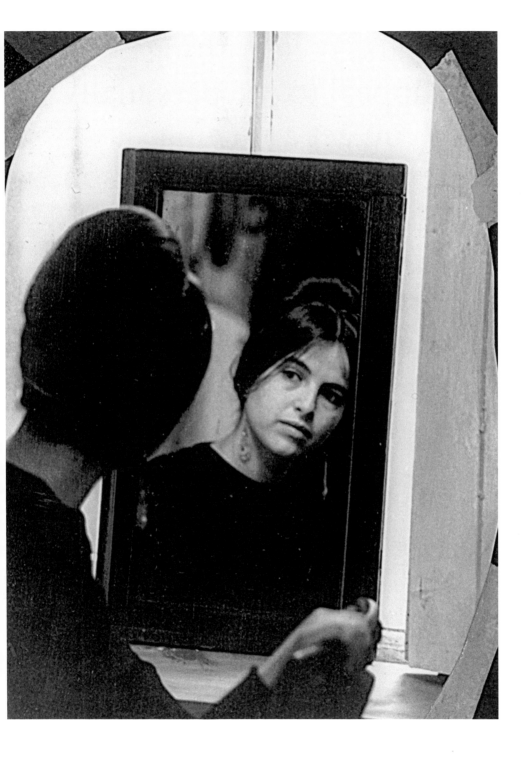

Eva Hesse, New York, 1966 79

I buy and collect things that appeal to me personally. Can you get anything better than when the person, the maker, the artist opens up to you and shows you what they do?

Eva Hesse, *No title*, 1960

Eva Hesse, *Oomamaboomba*, 1965

what she did was nothing that she had learned at an art academy. Everything came from inside her. The family circumstances were very difficult and later her relationships as well. All that left a mark; she must have been deeply scarred. That's what you keep encountering in her works and in the portraits. She was already critically ill, on top of coping with her experiences as a child and growing up with a schizophrenic mother who killed herself. And then she married the wrong partner, Tom Doyle, an extremely successful artist. She started exploring new media, materials, and forms. Her drawings are impressive, too. And her reliefs, in which she makes painting sculptural, are simply wonderful! She made magnificent sculptures out of fiberglass, all museum pieces. She did not produce much in her short life and many of her works went to museums at a very early stage. So that's where I have to go now in order to look at them.

LAURA Actually, to me, all of these works are self-portraits. Like this wedding picture made the year she married Tom Doyle. And they all have this dark side to them.

URSULA Sadly, I have too few drawings. These are her beautiful drawings. Watercolor or gouache. Then there's this *Mechanical* drawing (1965). And the reliefs made with materials she found when she was in Kettwig, Germany in 1964–65. Her oeuvre is very slim and was hotly pursued on the market—even during her lifetime.

LAURA Were you interested in Cindy Sherman as well?

URSULA Yes, but I didn't feel drawn to photography as an artistic medium. Naturally, I recognized Cindy Sherman's importance as a crucial figure in the art world, just like Eva Hesse. But I related more to Hesse, to her figurative painting. Sherman interested me even though I didn't quite understand the content. And even less, the prices. It seemed utterly abstract to me that anyone would pay so much for a photograph—and then one that was available in series. Later, I made the acquaintance of Cindy Sherman. Now she's practically an icon. But somehow, she passed me by. I missed the boat in Eva Hesse's case as well.

MICHAELA The strength and quality of the collection lies in your choice of focal points and in the exchange that you cultivate with your artists. Your goal is not to collect all-inclusively.

URSULA I concentrate on what I understand. I buy and collect things that appeal to me personally. Can you get anything better than when the person, the maker, the artist opens up to you and shows you what they do? Investment was never a priority for me. It's always been about the content of the art.

Ageless Art

Roman Signer

MICHAELA Roman Signer is an artist who already played a vital role in the early days of your collection and whose work you have consistently followed and collected over the years.

URSULA Roman's actions taught me that you can't simply plan art on the drawing board. He took a different path, working with natural elements and process. You never knew how it would come out. That fascinated me! His single-mindedness makes me think of Louise Bourgeois. For him, a process never comes to an end. He has so many thoughts, he goes off in so many directions, his work is so ramified, and covers so many different areas. And he is a master draftsman. He sketches the projects that he has in mind. In a way, he's easier to relate to than, for example, Louise Bourgeois. You couldn't have a personal relationship with her, like simply sitting down together or going out to eat. That was not an option. It's different with Roman. With him, you'd go out to eat and travel together and, in the process, you would get so much information and so many insights into his thoughts and ideas.

I had seen Roman's work at Galerie Wilma Lock and, of course, outdoors in public space in St. Gallen. There was a lot of mostly negative coverage in the papers about the *Wasserturm* (*Water Fountain*, 1987) that had been installed in a park in St. Gallen. So, you were always reading about Roman Signer.

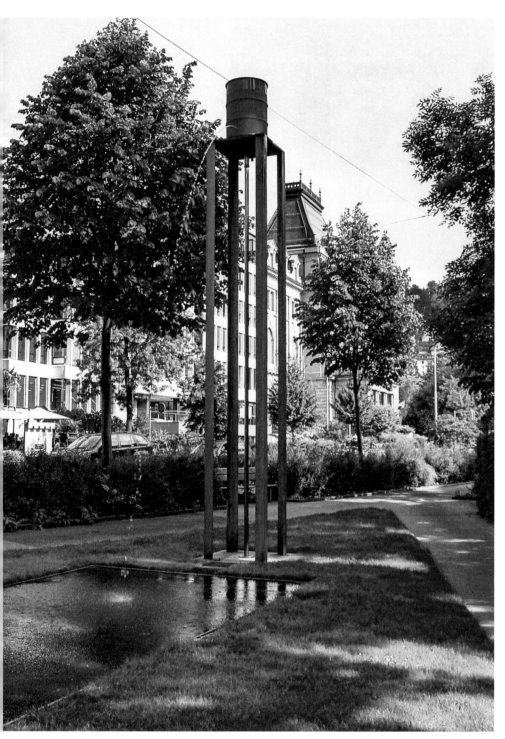

Roman Signer, *Wasserturm* (*Water Fountain*), 1987, sculpture commissioned
by Gewerbeverband, St. Gallen

Ursula with Roman Signer, 1992

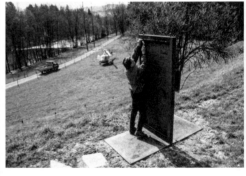

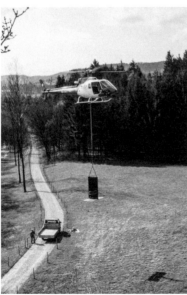

Installation of *Eisentor* (*Iron Gate*)
by Roman Signer, 1992

When I first met him personally, he was working in an old studio with an attic full of dusty things that he planned to use at some point. We walked around in the attic and he had a great idea for every one of the objects.

And at some point, I said, "Okay. Tell me what you need." He was teaching at the School of Design in Lucerne and wanted to stop in order to concentrate on his own work. So I bought my first piece, *Objekt* (*Object*, 1980), which is in the river.

LAURA Other works in your collection include projects such as *Leiter mit Stiefel* (*Ladder with Boot*, 1995), *Blauer Stern* (*Blue Star*, 1993), early water objects, photographs, and a number of other objects.

URSULA I often attended his actions, for example, his action with a helicopter in the 20er Haus (1995) near the Südbahnhof in Vienna. Roman is an extraordinary artist, who has not yet been entirely discovered. Hans Ulrich Obrist has done some groundwork. He said, "Keep an eye on Roman. He is interesting!"

MICHAELA Are there any works by Roman in your collection that you delight in or that you are particularly fond of?

URSULA I love his works involving water, objects like *Wasserleiter* (*Water Ladder*, 1971), *Treppe* (*Stairs*, 1976), *Grosser Tropfen* (*Large Drop*, 1973), or *Kraft des Regens I* (*Power of Rain I*, 1974). Unfortunately, you can't install works like that at home unless you have a proper workshop. I also appreciate his drawings. I like to see where an artist stands and what's important to him. Roman's drawings are especially enlightening; they are essentially a cross-section of his entire oeuvre.

MICHAELA The drawings, drafts, and models in your collection testify to your curiosity; you want to understand how things come about. You are always trying to probe the very origins of creativity.

URSULA Yes, having met Roman Signer, getting to know and spend time with him, has been a godsend. Not necessarily because of the sculptures or the actions, but because of him, because of who he is.

MICHAELA You traveled to Poland with Roman and Iwan.

URSULA Yes, that was in February 1993. It was cold, dismal, foggy, and wet. Poland was still pretty run down and way behind the times. We started out with an old car in Warsaw. Roman had been an exchange student there at the art academy for a year, which is where he met his wife Aleksandra. He spoke Polish, knew his way around pretty well, and took us to various places, to museums or archives. We also went to the Russian market, where they sold uniforms and boots. Then we drove to Lodz and spent the night in an inexpensive hotel. Pretty unsavory individuals were standing around in the lobby. I felt extremely uncomfortable as a woman. The rooms only had simple bit keys and if you didn't turn them sideways, they could simply be pushed through the lock from outside. And they promptly broke into Roman's room. He snored pretty hard and they robbed him while he was asleep. Everything was gone when he woke up—all the money, everything! It was a tremendous shock, but we went out to look around the city anyway. Roman was interested in secondhand bookstores—a passion that he shares with Iwan. In one of the stores, Iwan discovered a bibliophile rarity: a book about Picasso's exhibition in Poland. Then, we drove on through the countryside and stopped at a guest house somewhere. The food was simple, greasy, and peppery—and Roman ordered caviar. Iwan did the driving, and Roman, who can't drive, sat beside him in the passenger seat. I stayed in the back, huddled up in wool blankets. The windshield wipers went back and forth and Roman told wonderful story after story.
We drove to Kraków and then on to Auschwitz-Birkenau. It's an indelible memory. It was incredibly moving. We accompanied Roman to Zakopane, where Aleksandra comes from. We stayed with her family. They cleared out her room and their living room so that we could sleep on the sofa.
Roman made a number of works near Zakopane, which are recorded in Super-8 films, photographs, and videos, like

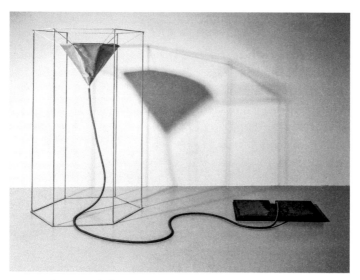

Roman Signer, *Kraft des Regens I (Power of Rain I)*, 1974

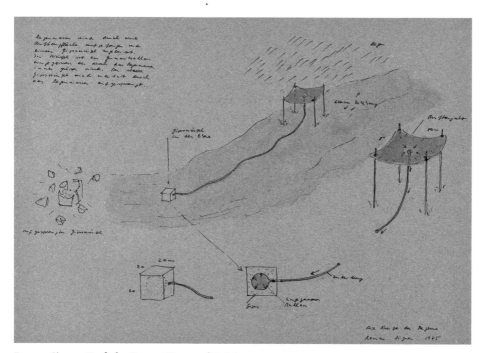

Roman Signer, *Kraft des Regens (Power of Rain)*, 1975

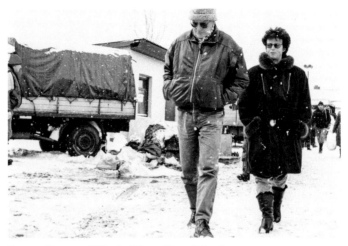

Roman Signer and Ursula, Nowy Targ, Poland, 1993

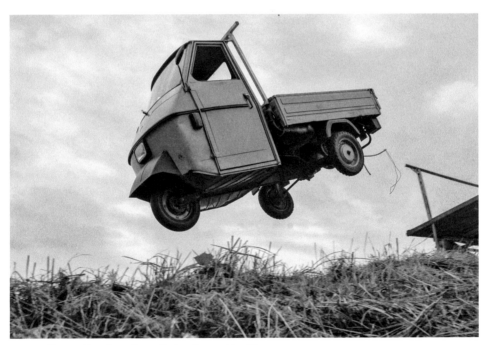

Roman Signer, *Piaggio on Jump (Poland)* 2003 (detail)

Piaggio on Jump (Poland) (2003). Roman and I are deeply befriended. He is ageless, not just in his work, but in his appearance as well. To me, he is crucial to understanding contemporary art. Absolutely crucial! There isn't much need for conversation. You just have to listen and look. And then you begin to come to your own conclusions about him and his work. You don't have to talk about it. You just feel it and let it happen! That's what makes it so special, so different from everything else.

Sculpture of a Different Order

Franz West

MICHAELA Franz West has been represented in your collection since 1994 and he plays an important role.

URSULA Yes, a very big role! He's one of those artists who went their own single-minded way. He wanted viewers to interact; he invited them to pick up the sculptures and literally use them. I see a connection between him and Berlinde De Bruyckere. In both cases, their work is about sculpture of a *different order,* different from beautiful, shiny figuration, like, for instance, Rodin. To me, West's early *Adaptives* are of a *different order;* they have no obvious form. And then the pedestals! Franz simply used a cupboard or a table, or just made one out of rebar. The most important thing for him was conversation and company. Eating and drinking together, talking until the early hours of the morning. He made objects to sit on and demonstrated the practically unlimited potential of art. Art used to be sacrosanct. God forbid that anybody would touch it! Instead, Franz said, "Now, sit on it!"

He put the bed, table, and cupboard that he had in his studio on wheels so that he could move them around as he pleased. He liked the mobility, being able to change the space around him to suit his mood. And that's what led to making sculptures you can sit on.

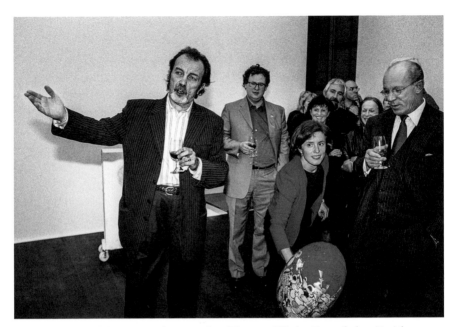

Franz West: Vom Feinsten, opening reception, Hauser & Wirth & Presenhuber, Zurich, 1999; (*left to right*) Franz West, Iwan Wirth, Manuela Wirth, Ursula Hauser, Hansruedi Wirth, Elsa Hotz, and Franz Wassmer

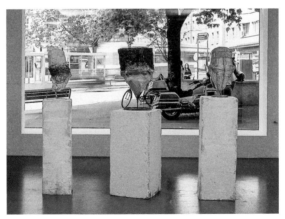

Franz West: Colabs and Combos, installation view, Galerie Walcheturm, Zurich, 1997

And then there are his *Lemurenköpfe* (*Lemur Heads*, 1992).
For Franz, the sculptures were trash cans. People are meant
to fill them up with fresh garbage; they're supposed to
stink and rot! They even have a flap, so that you can empty
them again. And when you get closer to them, there's an echo.
He was playful about everything he did. It wasn't always
beautiful and was often irreverent, but always full of humor.
Like his pissoir *Étude de Couleur* (*Color Study*, 1991). The first
time I saw it was in Nice. It stood directly above the cemetery.
And men actually used it, peeing down on the graves from
above. Urinous, not just ruinous. [Laughs]
I saw my first exhibition of Franz's work at Galerie Wilma Lock
in St. Gallen. Later, we met him personally at the Walcheturm
with Eva Presenhuber. We often drove to his old studio
in Vienna's third district. We celebrated his fiftieth birthday in
Porto with him. And when we traveled to Australia with
him afterward, we even lugged his favorite wine along for the
opening of the exhibition in Melbourne. Franz had a thing
about luxury, although I don't know if he really knew anything
about the wine we brought. I'm not sure he was really a wine
lover; it just had to be the most luxurious, the most expensive.
He never learned to drive but he loved having himself chauf-
feured around.
We often met with David Zwirner in New York, at David's
Broadway loft that was furnished exclusively with pieces
by Franz West. You could order big tables from him and when
they got dirty, you would just apply another coat of paint.
A work of art integrated into life.
I bought an early work by Franz at Galerie Walcheturm. Eva
Presenhuber took the gallery down a different route. Pictures
weren't just mounted on the walls, you could actually live
with art and integrate it into your life, like West's table painted
by Herbert Brandl.
He used a door for the tabletop and the legs are rebar. Actually,
the table is too high; it's on a platform with holes in it for the legs.

Screws go all the way through the top, sticking out danger-ously underneath. Franz was always devilishly delighted when women tore their stockings on them because it was actually meant to be an office table. When the table was not placed in the holes, it had the ideal height of a bar. Then you could drink together and talk, rather than conventionally sitting across from each other on chairs. Franz wanted people to get close to each other. That's why the divans in *Rest* (1994), for instance, are juxtaposed so that you can't help looking at and speaking to one another. But basically, they are sculptures.

MICHAELA It seems that what appeals to you most about Franz West is the way he turned his back on classical sculpture and ignored its boundaries. Chairs and sofas are perfectly ordinary pieces of furniture, but West made so very much more out of them. He turned them into a social space, a place and opportunity for an encounter.

URSULA Like the sofas, he didn't make them for a museum; he wanted them to be used. Like the multiples, for instance, the lamps: they don't really work but they are beautiful sculptures. In a way, he handled his exhibitions like he did his fiftieth birthday party. It was such a joyous celebration with so many friends, curators, critics, and collectors. It lasted two days. A real family party! I remember that he wasn't ready for an opening once. The exhibition simply wasn't finished! So he took the bull by the horns and invited all the guests to hang the show with him. His motto was to do everything together: eating, drinking, hanging pictures, sitting on sculptures, but not just side by side—always face to face. Always.

LAURA You have sculptures and furniture by Franz West throughout your house. You live with them.

URSULA I have even put fabrics aside, African fabrics. When I see them somewhere, I buy them, because they occasionally have to be replaced. And obviously, they have to be African! Nothing else will do.

Franz West, *Am 28. (On 28th)*, 1999,
collage for Ursula's birthday

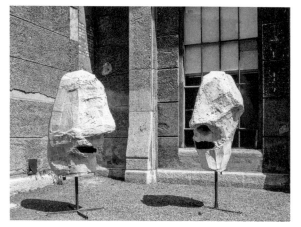

Franz West, *Lemurenköpfe* (*Lemur Heads*), 1992

Franz West, *Rest,* 1994, installation view, Dia Center for the Arts,
548 West 22nd Street, New York, 1994

A Passion for Painting

Francis Picabia

URSULA Iwan also convinced me that Picabia was a crucial figure
in the history of art. I couldn't understand why his painting was
so important. I always let myself be guided by my feelings,
my intuition. Then I had the opportunity to acquire a larger
group of works through Galerie Neuendorf in Cologne
and started studying him. There must have been about fifteen
works in various formats, from several phases of his work,
and in different styles. I became quite attached to some of them.
Others I sold again but five or six are still in the collection,
for example, *Double Soleil* (*Double Sun*, 1950), *Transparence*
(*Transparency*, ca. 1928–29), and *Villejuif* (1951), which is one
of the last oil paintings he ever made. Unfortunately, there
weren't any drawings, but later I found some elsewhere. And
then I added works from the 1940s, the nudes. I wanted to
establish his art as a highlight in the collection. Olga Picabia
had heard about our acquisitions and we wanted to meet her.
She was Swiss and came from the Bernese Highlands. Born
into a working-class family, she spent a year abroad with
the Picabia family, and there she stayed. They became lovers
and the relationship lasted for the rest of their lives. Picabia
was a bon vivant, lived it up, racing cars in the 1930s, parties,
a man about town, big celebrations, utterly extravagant. He
was notorious for his wanton abandon.
We went to see Olga in Paris and spent a pleasant afternoon
with her. She had a lot to tell us, and the studio was still the
way he had left it. There were even some paintings on the easel,
among them a portrait of Olga that I instantly fell in love with.
Sadly, I hesitated at the time. It ended up being sold two or
three years later, so I don't have it, unfortunately. I remember it
exactly, I could draw it. It was the painting. That's what happens
sometimes when you ignore your feelings, when you think the
price is too high or it's just not an option. And if you hesitate,
you'll probably never get a second chance.

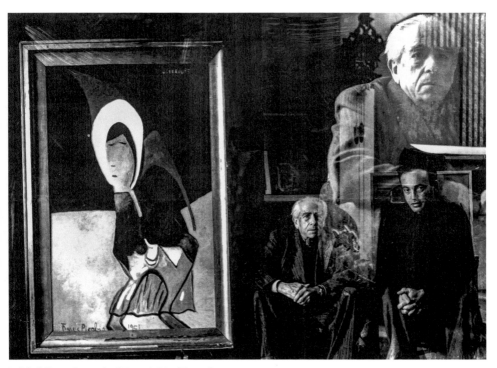

Michel Sima, *Portrait of Francis Picabia*, n.d.

We visited her once again, later. She was fascinating, a grand lady with great charisma. She was tall, a robust Bernese lass and, at the age of ninety plus, she still drove her old Peugeot to go on holiday in Switzerland. She spoke the Bernese Swiss dialect with me and occasionally French. She lived alone, with no domestic help. She liked going out and we went to her favorite restaurant, a seafood brasserie. She loved it. She must have been around ninety-two at the time, she got dressed up for the evening and told us a lot about Picabia. I became more and more engrossed in his work, bought all kinds of books and catalogs, and I'm still doing it.

MICHAELA That was before everybody started talking about Picabia. Artists were interested in him, but the art market and the museums hadn't discovered him yet.

URSULA As far as I know, Picabia came from a well-to-do family and did not necessarily have to sell his art. His work probably didn't come on the market until later after the entire fortune had been squandered. I think Neuendorf was the first one to show Picabia in a big way. He was originally part of the gallery scene in Cologne, like Rudolf Zwirner, Kaspar König, and Walther König. People would often get together, for example, at Rudolf Zwirner's gallery to find out about collectors and, of course, about artists as well, like Richter and Blinky Palermo and all the Deutsche Wilde.

So everything is connected. We mounted our first Picabia exhibition at the Löwenbräu gallery in Zurich with works from Neuendorf. It was accompanied by a very beautiful catalog that contained a conversation with Olga Picabia!

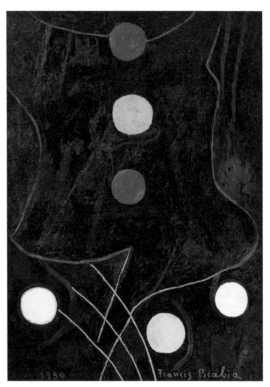

Francis Picabia, *Double Soleil* (*Double Sun*), 1950

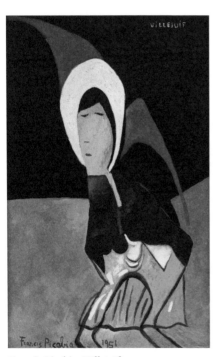

Francis Picabia, *Villejuif,* 1951

John McCracken, New Mexico, 1996

Rachel Khedoori, Jason Rhoades,
and Ursula, 1993

Off to California!

MICHAELA You and your partner André Remund went on a number of trips to the United States at the end of the 1990s—New York, Chicago, the West Coast, and New Mexico.

URSULA I went to New Mexico because of Agnes Martin. I had a few of her works and was focusing on her. We also met with John McCracken during that trip. Unfortunately, a visit to Bruce Nauman's studio didn't work out, and Agnes Martin was sick the day we had planned to see her. We finally went to the Georgia O'Keeffe Museum, a wonderful building. The area is so barren, it really impressed me. I have always liked Georgia O'Keeffe's architectural drawings, her paintings of buildings and landscapes. Unfortunately, I never managed to acquire anything by her. But I do have two or three works by Maria Lassnig that are similar in nature. One of her earliest works, the *Nockgebirge* (1954) reminds me of O'Keeffe.

A Big Family

MICHAELA One of the highlights of your collection began to take shape in the 1990s. You often went to the West Coast, especially Los Angeles, and met a number of artists there. What are your memories of these times and encounters?

URSULA Yes, we spent a lot of time in Los Angeles, where we met Paul McCarthy, Jason Rhoades, Rachel and Toba Khedoori, Richard Jackson, Hans Weigand, and also Raymond Pettibon. We had so many encounters, wonderful exchanges, going out to eat, and celebrating. The artists got along very well; they were very accepting of each other. Paul and Jason were actually neighbors. Paul and Richard were Jason's teachers at UCLA. That was how they met. We always did things together.

Jason Rhoades in front of Kunsthaus Zürich during the group exhibition
Freie Sicht aufs Mittelmeer, 1998

Jason Rhoades on *The Future Is Filled
with Opportunities (Ridable Steer)*, 1995
in Los Angeles, 1995

Ursula in Los Angeles, 1992

Jason Rhoades

URSULA Jason was much too young when he died. I didn't have the chance to really study his work with him. Everything broke off so abruptly. He is an important figure; he captured the zeitgeist but his philosophy is hard to understand. He turned his back on painting, on the beautiful, classical genres. Instead, with a couple of his peers, he defined a new direction in art. It's much more challenging and more intense to immerse yourself in one of Jason's installations than to study a beautiful painting. When you look at a still life, you appreciate the colors; it is well done. Jason's work was provocative. Most people just threw their hands up, pooh-poohed it instead of asking themselves: how did this come about? Where do we stand now? I enjoy trying to answer questions like that.

MICHAELA Jason was not a conventional studio artist. His car, his vehicle, was his studio. How did that strike you at the time, in the mid-1990s?

URSULA Jason used to stay with me in Switzerland and fell in love with my Ferrari—head over heels in love. But since he didn't have any money, we made a deal: he gives me his old Caprice to use when I'm in Los Angeles, including him as chauffeur, and he gets the Ferrari. We shipped it to him. The Caprice was an old car and always stank of oil or diesel or something. So Jason would spray around some Allure by Chanel. The perfume made the stench twice as intense, just plain too much of a good thing. He also built videos into it and turned it into a work of art on wheels.

While still alive, Jason gave a part of "my" Ferrari back to me—namely, a suitcase. It was such a small car and so it came with seven pieces of leather luggage perfectly designed to fit in the car, for instance, one for shoes, one for clothes, etc. The one he gave back to me was filled with porn magazines and this is how part of the Ferrari came back to my collection. The same thing with the Caprice! The engine soon gave out completely.

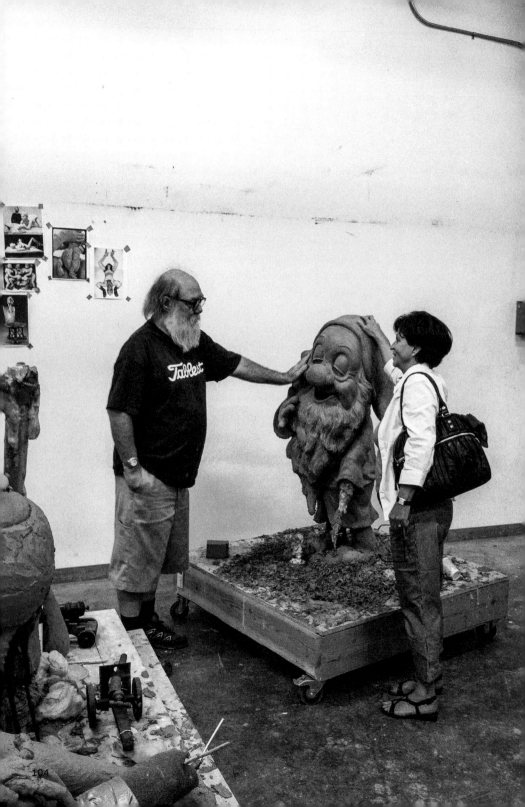

The old engine block is now a table and belongs to my Jason collection.

Naturally, mobility was an issue. He said to me: "You can find art everywhere." That in itself was novelty enough! And then what he did with his actions, recording them in other media, in video, film, and stills. The change of media intrigued me with artists like Pipilotti Rist and, of course, Paul McCarthy, too!

Paul McCarthy

Paul had a small, very small studio in Pasadena. It was literally bursting at the seams because of all of his projects. He had only two or three assistants in those days and his wife Karen naturally belonged to the team! So we were able to trace the development of his work and how it kept getting bigger and bigger. Los Angeles as a film metropolis was fertile territory for him—the themes, the stage sets. I think he makes fabulous stage sets. His films and everything he did emerged against the backdrop of these sets.

LAURA The first work you acquired by Paul McCarthy was *Apple Heads on Swiss Cheese* (1997–99), with the accompanying drawings and plaster models.

URSULA Yes, that was really important. I had seen the drawings and models in the studio. I practically begged for them! It was an absolute must for me to buy the drawings along with the works themselves. Paul was focused on his exhibition in St. Gallen and his new works were related to Switzerland. It was his first major exhibition in Europe, and just imagine—in St. Gallen! He had carte blanche, worked out huge projects like *Mechanized Chalet* (1993/1999), designed to fold open and close up again. And then he made his *Heidi* works! Paul had studied Switzerland, its history and traditions, in great depth.

LAURA Paul McCarthy's sculptures were your primary focus rather than his installations.

Paul McCarthy and Ursula in the artist's studio, with a model for *White Snow Dwarf, Sleepy #1 (Midget)*, 2010

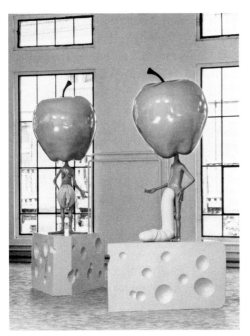

Paul McCarthy, *Apple Heads on
Swiss Cheese*, 1997–99

Paul McCarthy, *Apple Heads on
Swiss Cheese*, 1998

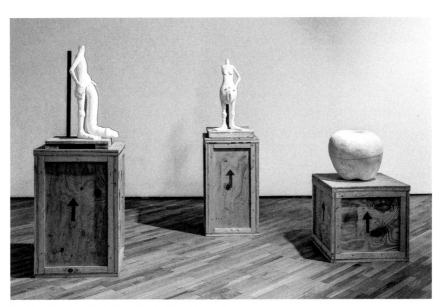

Paul McCarthy, *Model for 'Apple Heads'*, 1998

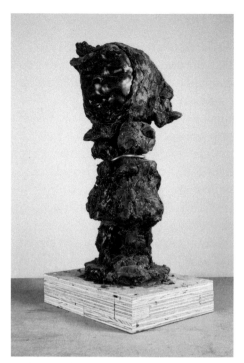

Paul McCarthy, *KKKKK*, 2009

Paul McCarthy, *Forests*, 1984

URSULA I first encountered his work at Luhring Augustine. I remember sitting in a small movie theater with Marc Payot and having to wear masks. We watched a video, *Pinocchio Pipenose Household Dilemma* (1994), and I was fascinated by his ability to capture the audience and make us part of the work.

MICHAELA It seems to me that, in the course of those years, a new quality emerged in your exchange with artists. You often got together with artists and visited them, which enabled you to follow in detail the making and emergence of new works. Works about Switzerland were created, like those by Paul, which then found a home here—in your collection.

URSULA I have one of his earliest drawings; he dedicated it to Karen when Mara was born. And the way it often is with artists, he needed money so he entrusted me with this extremely personal, intimate work. He trusted that I would keep the drawing, that I am not a dealer. I could have sold it any number of times, but it will stay with me as long as I am here! I owe that to him. It's a vital, key work for me.

There's another important work. A portrait of Karen, made of wax, a one-off, not a multiple. He entrusted that to me as well. He trusted me implicitly; he knew I would keep the work and would never put it on the market. And there are other works in my collection today, like the dummies and models of the sculptures he made for Middelheim, the *Inflatables* (2006–07), that he didn't want to sell either. The models are extremely important works; they should actually be in a museum!

MICHAELA Your fascination is connected with following the creative process. You were so close to him the whole time and able to see how he works, how he thinks, how he implements his big projects.

URSULA I think the decision to acquire these models was made in the studio. I was convinced that it is important art historically to preserve them and keep them together in one place—which has turned out to be in my collection.

LAURA Another very important work by Paul that you acquired later is a group of nine dwarfs.

URSULA It's about Snow White. Funnily enough, he made nine instead of seven dwarfs and he made the complete group three times. I was the only one able to acquire the entire group. It is important for an institution or collector to keep a group like that together. I managed to arrange that with Paul. He realized that it was about my private collection and not a money-making affair with the intention of generating as much profit as possible and as quickly as possible by dealing with the work. The fact that these works are in my collection illustrates how much he trusts me.

Going Public I: The Lokremise St. Gallen

MICHAELA In 1999, you, along with Iwan and Manuela, rented and
refurbished the former train depot in St. Gallen called the
Lokremise. You used it, until 2004, to present selections from
your collection to the public. How did that come about?

URSULA We had acquired large works and installations and had no
means of showing them. To me it was important to share them
with the public. I have very close ties to my hometown and the
canton and was intent on doing something here in St. Gallen.

MICHAELA Did you feel that you owed it to the artists?

URSULA Yes, definitely. Naturally, we debated over the right
location. Zurich could have been an option, too. But the city
already had various platforms, while St. Gallen is a region
that tends to be forgotten, even though it has so much to offer:
the textile and embroidery industries, the art museum, the
medieval library, and much more. It's like a little cocoon and
I wanted to carry out my project there. St. Gallen's former
building commissioner, Franz Eberhard, helped us out and
found the property. He was very enthusiastic about our idea.
The depot had actually been put up for sale and developers
wanted to build a shopping center there. Through our efforts,
the Lokremise was classified as a historical monument, which
meant it couldn't be torn down. After we left, the politicians
realized what a marvelous cultural venue it is, a great benefit
to both the city and the canton. That is so gratifying. The venue
now hosts all kinds of cultural activities; it accommodates the
municipal theater, a restaurant, part of the art museum, and
the movie theater KINOK. And it will stay that way!
We have found a better solution for my collection in private
spaces. We don't have to invest as much in exhibition operations
as we did in St. Gallen. A public operation is very expensive and
with little reward. Not enough visitors and not enough funding.
The idea behind the Lokremise in St. Gallen was to create a place
for encounters. Not a gallery or a museum with strict opening

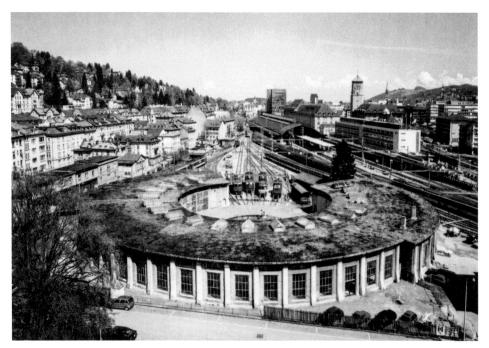

Lokremise, St. Gallen, 1997

Richard Jackson, André Remund, Karen McCarthy, Iwan Wirth, Manuela Wirth, Paul McCarthy, and Christian Scheidemann, Lokremise, St. Gallen, 1998

hours where you do what you want to do in half an hour and go home again. We wanted something different. As in Somerset. Hauser & Wirth's project in Somerset has grown and now offers even more in the way of hospitality and education.

MICHAELA At the Lokremise, you already had a cafeteria, a bookshop, and a diverse educational program including tours and workshops for children. Much of what you built up in St. Gallen can now be found at Hauser & Wirth's Somerset and Los Angeles galleries.

URSULA That's true. But in St. Gallen, it never really got off the ground. It would have required more support, possibly a larger region or more investment. It wasn't easy.

LAURA But the collection took concrete shape.

URSULA It certainly did. We not only mobilized the local public and friends of the arts; artists came from all over the world. We had a lot of visitors and there was a gap when we left.

MICHAELA There is a wonderful photograph from 1998 with Paul McCarthy, Richard Jackson, Jason Rhoades, and Iwan Wirth on the turntable inside the Lokremise. To me, that picture says everything. For you as a family, as collectors and with a gallery, exchange with artists is absolutely crucial.

URSULA The artists were always involved! Nothing ever happened without getting everyone together. Even with the architect Paul Robbrecht from Belgium, we commissioned someone who wasn't just famous like Calatrava or Koolhaas, but an architect who was familiar with projects in the fields of culture and art. The artists contributed a great deal. The entire project ended up costing more but it was worth it. We didn't want a white cube where you simply hang art. We were constantly consulting Paul or Jason: How? What? Tell us? What do you think? They were informed about everything and involved in what we wanted to do.

Iwan had the vision; artists are the capital of a gallery. You can't operate one without them. And he knew that they have to be participants and so we were always engaged in exchange with

Paul McCarthy, Jason Rhoades, Richard Jackson, and Iwan Wirth,
Lokremise, St. Gallen, 1998

Marc Payot and Iwan Wirth at Hauser & Wirth's 20th-anniversary celebration,
New York Public Library, 2012

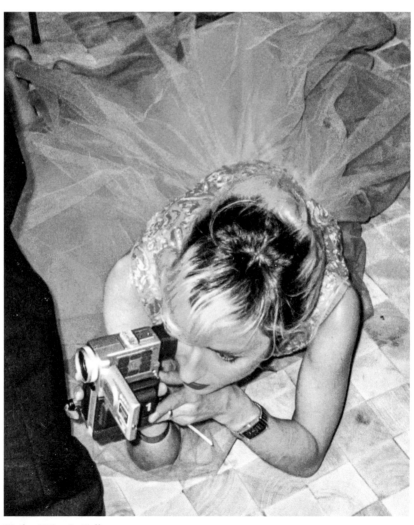

Pipilotti Rist, St. Gallen, 1999

them. Jason went on vacation with us. We were really friends. As we were, for instance, with Jerry Gorovoy and Roni Horn. That way artists also get to know each other. One of the most wonderful moments for me was when all of the artists joined us at the New York Public Library to celebrate the twentieth anniversary of the gallery. That was simply marvelous. Really one big family!

Pipilotti Rist

Pipilotti belonged to the family, too. We spent a lot of time together. I often went to her studio and we had a lot of personal contact as well. She is a collector herself, collects clothes and secondhand things, anything in which there is life, proof of life—and then incorporates these things into her work. She has an immense collection of vintage clothing. That appeals to me! And we share the same tendencies, like hanging onto everything. She sends me something from every trip she takes, for example, a sari from India.

We started collecting Pipilotti's work in the 1990s and supported her that way. It gave her the opportunity to buy materials so that she could go on working. The technology was expensive. It's a give and take, but, of course, interest in her work was always paramount.

MICHAELA What are the first works you acquired by Pipilotti for your collection?

URSULA *The Elektrobranche (Pipilampi grün)* (1993) and then the video *Pamela* (1997).

MICHAELA The video shows a stewardess strolling down the aisle in an airplane. But the roles are reversed and she lets the passengers kiss her feet.

URSULA Yes, being a stewardess was a dream job in those days. A wonderful image, a superwoman, a fairy queen. A celebration of femininity. That's why I liked it so much. I bought mostly smaller works by Pipi, like the *Bar* (1999), in which three films are projected through three bottles. You can put it up at home.

Pipilotti Rist, *Elektrobranche (Pipilampi grün)*, 1993

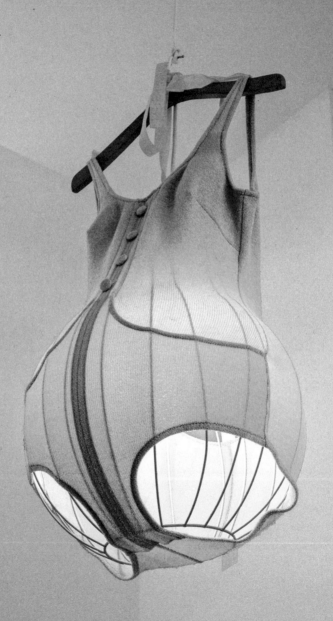

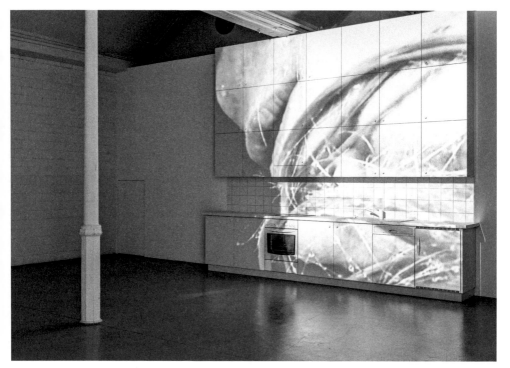

Pipilotti Rist, *Regenfrau (I Am Called a Plant)*, 1998–99

Pipilotti Rist, *Pamela,* 1997 (video still)

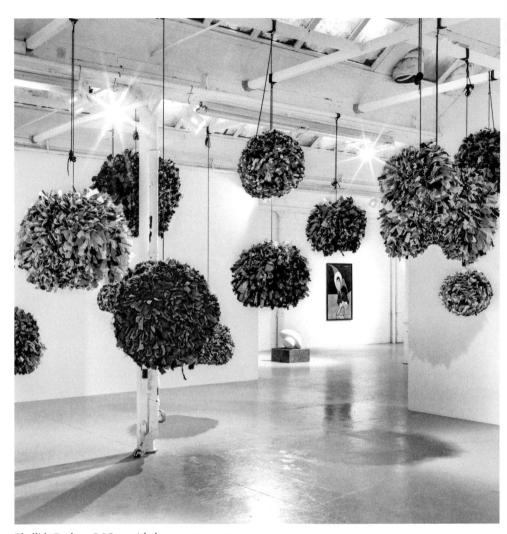

Phyllida Barlow, *RIG: untitled; pompoms*, 2011

MICHAELA "Home"—that's a keyword because what you like most is to live with the works in your collection!

URSULA Basically, yes. But as the artists moved on, they kept making bigger installations. So much so that I thought what fun it would be to have an expanded living room in which I could see and show works, for instance, Louise Bourgeois's *Spider* or Pipi's large pieces, like *Regenfrau (I Am Called A Plant)*, 1998–99. The question is whether it is meaningful to buy larger works, like a big film installation. To me, it only makes sense if they aren't just standing around, packed away in boxes, and only out on loan once in a while. They have to be installed somehow, so that you can see them. Sometimes, I come across an installation that makes me want to put my bed in it, for instance, Phyllida Barlow's *Pompoms*. I would have loved to sleep in there!

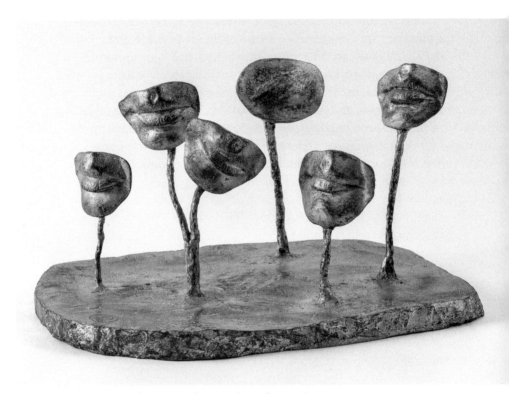

Alina Szapocznikow, *Bouches en Marche* (*Mouths on the Move*), 1966–70

Surrealism Is Feminine: A Fledgling Passion

MICHAELA You have several women artists of an older generation in your collection: Carol Rama, Alina Szapocznikow, Eva Hesse, and Nicola L.—women whose lives are very familiar to you.

URSULA Yes, an older generation that always made young, contemporary works!

MICHAELA And you also collect artists of a younger generation: Toba Khedoori, Berlinde De Bruyckere, Pipilotti Rist. Which artists did you start out with in your collection?

Meret Oppenheim

URSULA At the very beginning, Meret Oppenheim and Niki de Saint Phalle. I was impressed early on by those two Swiss artists and went to the few exhibitions about them that were organized at the time. *Imago,* the film about Oppenheim wowed me; it's such a wonderful portrait of her! It was only later, in 1994, that I was able to acquire something by Meret Oppenheim. The *Pelzhandschuhe (Fur Gloves with Wooden Fingers,* 1936) were the first thing I purchased; it was one of the first works on the art market as a complement to *Object,* her fur-lined teacup and saucer, acquired by the Museum of Modern Art in 1937. Everybody knew about it, of course. It had put her on the map, but it was like a soundbite to which she was always reduced. The fur works have a completely different material quality from the paintings. Meret was already using a variety of materials when she started out, like oats, or stones, and marbles, making collages like the *Hafer-Blumen (Oat Flower,* 1969). Artists started moving in a different direction in the 1960s with regard to materials, representation, and message.

LAURA How did you come across Meret Oppenheim and Niki de Saint Phalle?

URSULA That was the scene in Switzerland. Meret Oppenheim, Jean Tinguely, who was Niki de Saint Phalle's partner. You would

Meret Oppenheim, *Pelzhandschuhe*
(*Fur Gloves with Wooden Fingers*), 1936 123

Meret Oppenheim, *Hafer-Blumen* (*Oat Flowers*), 1969

read about her in the press and there were exhibitions. I didn't buy anything at the time. I didn't know enough about it and the prices were already pretty considerable.

MICHAELA A number of works in your collection, like those by Meret Oppenheim, Alina Szapocznikow, and many others, are related to Surrealism.

URSULA Surrealism has always captivated me. The men, too, Salvador Dalí and Tanguy, that was the avant-garde. I looked at a lot of work and bought catalogs, but I didn't want to own it. Peggy Guggenheim was a key figure for me. She lived in the age of Surrealism. I found her extremely interesting and read the biographies in which she describes the Surrealists and the time in which she lived. Unfortunately, she supported primarily male artists.

Roni Horn

MICHAELA Can you tell us about your first encounters with Roni Horn and how you acquired her works?

URSULA I was particularly taken with her photographs, for instance, the birds. Roni Horn takes a different approach to photography than, say, Thomas Ruff or Tillmans. Her photographs make you think of something handcrafted. They have a structure, a surface that you can almost touch. Her photographs are basically a form of painting.

LAURA You have a self-contained group of glass objects, drawings, brass cubes, and aluminum rods.

URSULA The materials Roni uses for her sculptures remind me more of architecture. New materials, not the classical pink, almost fleshy marble that you see in Louise Bourgeois's art. Roni's sculptures are more aloof. Look at her use of glass! The way she presents it makes you wonder just how she managed to construct the object. She's like an engineer when she plans her works. A good example is *Rings of Lispector (Agua Viva)* (2004), consisting of rubber floor tiles, with its literary allusions and intellectual slant. Roni doesn't simply address us visually;

Ursula and Roni Horn, 2016

Roni Horn, *Rings of Lispector (Agua Viva)*, 2004

she addresses all of our senses. The glass sculptures seduce you into touching them. And you walk on the rubber tiles with your bare feet so that you feel the inscriptions under your toes, which adds an erotic component. All that requires a great deal of sensitivity and I feel that in all of her work. Think of the way she meticulously reassembles her drawings and collages, and with an underlying strategy that viewers don't perceive at first sight. Her works are so precise and reduced, like the copper sphere or the *Gold Field.* As I said, works like that have something in common with architecture.

MICHAELA Did you meet Roni through other artists in New York? Through Jerry Gorovoy, who is a very good friend of hers?

URSULA Louise Bourgeois drew my attention to Roni and, naturally, the exhibitions that I saw of her work. It really clicked when I went to Iceland with her for the opening of *Library of Water* (2007). That was the most beautiful experience I've ever had! The exhibition location was two and a half hours away from Reykjavík, to the west of the island, in Stykkishólmur, a barren, dreary landscape. The clouds move by faster overhead than they do here; everything is so tangible. In *Vatnasafn / Library of Water* (2007), Roni filled glass columns with water from various springs. Water isn't water; it is enriched with different minerals depending on where it comes from. This work reveals Roni's concerns, or preoccupations. For the opening, she organized singing with a young actress and a small choir. It was exactly like Iceland, barren and yet very, very intense. I was surprised by the quality of the choir. In addition, someone read a text out loud. We made a stop on the way while driving back to Reykjavík. The air was fresh and cool. Roni said, "Let's lie down in the grass." And so we lay down in the dry grass of the steppe; it was about two feet tall. Sheltered from the wind, we watched the clouds and felt the warmth of nestling in the grass. We must have lain on the ground for a good half hour. Something similar is reflected in Roni's works, the blue and white, the clouds, the colors, the power and

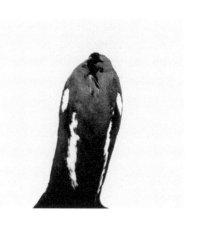

Roni Horn, *Untitled, No. 2*, 1999

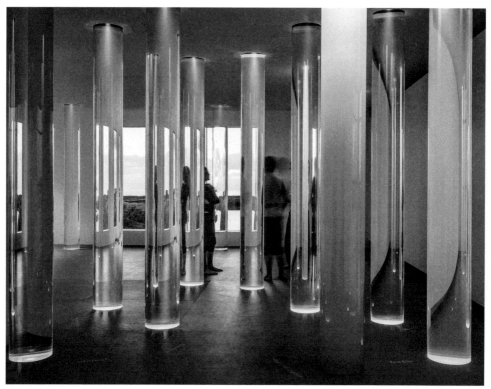

Roni Horn, *Water, Selected*, 2007, and *You Are The Weather (Iceland)*, 2007, permanent installation, *Vatnasafn/Library of Water*, Stykkishólmur, Iceland

primal force of nature, the water, the geysers. Iceland is a good place for her. She worked there for years.

Her glass objects should be shown in natural daylight so the light is refracted by the glass. That way you can see the nuances— intricate bubbles, a tiny hairline crack, and so on. You see that only when the lighting is right. On second, third sight, you can understand Roni Horn's work much better. But the best thing is talking with her!

Making Discoveries!

LAURA Since 2003 and particularly until 2008, you opened up the collection, broadening it by collecting more work by such artists as Maria Lassnig, Berlinde De Bruyckere, Lee Lozano, Carol Rama, and Alina Szapocznikow.

Alina Szapocznikow

URSULA Yes, I felt I needed to catch up! And I had time to go to art fairs. Iwan and Manuela had moved to London with their children, which meant a reduction in my grandmother duties. I started traveling more often and kept coming across new things, like the work of Nicola L. that I discovered at FIAC in Paris. I became acquainted with Alina Szapocznikow's work at Galerie Gisela Capitain. My first acquisition was *Bouches en Marche* (*Mouths on the Move*, 1966–70). Later, I studied her art in greater depth. Like many others in my collection, there is one piece that you can touch. You can play with it when it lies in front of you.

LAURA Is that a kind of palm stone?

URSULA Yes, exactly. You can pick it up and hold it, like Franz West's *Adaptives.*

MICHAELA In other words, a work that is very physical, related to the body although not by depicting it; it is more related to the viewer's body.

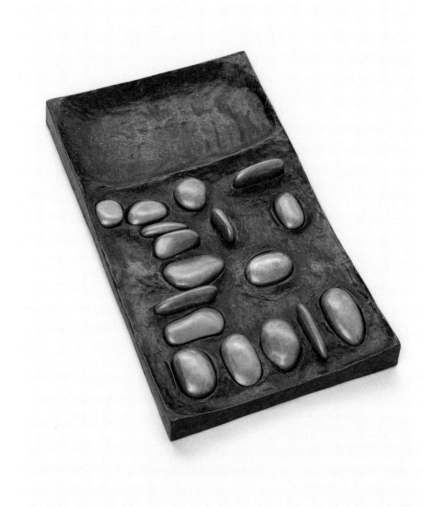

Alina Szapocznikow, *Jeu de galets* (*Pebble Game*), 1967

URSULA Exactly. Sometimes she shows parts of her own body, like the *Bouches en Marche*. When I speak to people, I look at their eyes, lips, and hands. That's what attracts my attention. I get an idea about someone very quickly, through what they say with their lips and through their eyes, whether they look at you directly. Those aspects are important to me. Szapocznikow was always doing something with body parts. She was diagnosed with breast cancer in 1969 and died a few years later. The shape and materials of the body parts mirror her cancer. It's a form of atrophy, for example, when only half a head is hinted at or the sculpture shows the fragment of a face, where only the lips are still complete. When I first saw her work, I knew nothing about her life. But you sense the illness, the cancer gnawing at her, consuming her. That said something to me. She also converted sculptures into objects of use, like lamps or light fixtures. *Stela* (1968)—or the black Madonna, as she calls it—is the highlight in my collection of Szapocznikow's work: the body parts are put together like a puzzle, some of them are covered up, you can make out the legs and here the feet. Or are they hands? I love the way the work oscillates between figuration and abstraction. She detaches body parts, takes them out of context, there is neither a top part or a bottom part, nothing. It's simply an erotic body, not a slender one. A flat stomach would be absolutely nothing, but the slightly bulging belly is another story. Naturally, the belly button is in the center, the origin of life. I can't explain my fascination art historically. I see the figure in *Dessert V* (1970) as Twiggy. In the 1960s, Twiggy was the first model to go for the skinny look, and I mean skinny. To me, it's the face as well, short hair, actually just a transformative figure, not a beauty, but she embodies that for me, that's what I associate with it.

LAURA In some of the objects in this series, Szapocznikow embedded photographs of Twiggy in polyurethane.

URSULA Here, I would certainly say she was an artist who made sculpture of a different order. For example, using chewing gum

131

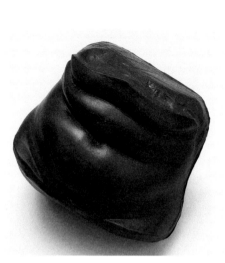

Alina Szapocznikow, *Ventre-coussin (belly cushion)*, 1968

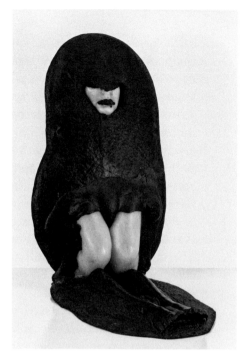

Alina Szapocznikow, *Stela (Stéle)*, 1968

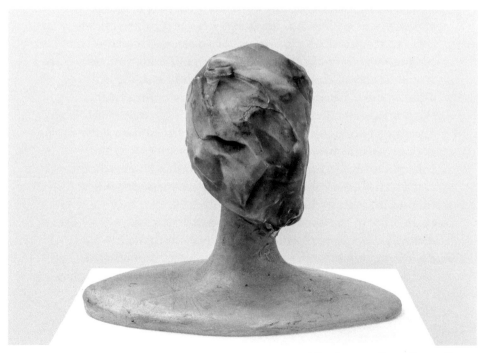

Alina Szapocznikow, *Dessert V*, 1970

that she had chewed. She simply put the soft material on the edge, on the abyss, thus letting the figure take shape. She made an entire series that way.

MICHAELA The sculpture is created by natural forces and by chance. Does that have to do with your life as well and with the way you approach life, accepting chance and being able to let go?

URSULA Yes, somehow, I've come to realize that you can't plan life well in advance. It always turns out differently. The same thing applies to art. In the final analysis, you have to be willing to accept it as it is. And in the case of artists, the result is usually a beautiful work!

LAURA You collected both drawings and sculptures by Szapocznikow. The drawings are very explicit. They are actually a beautiful complement to the work of Ida Applebroog or Carol Rama.

URSULA I think drawings are the foundation and point the way to what comes afterward. A lot of what Szapocznikow later tried out with a variety of sculpture materials originally took shape on paper. She committed forms to paper that had been floating around in her head for a long time. You can't tell whether it's a flower, part of the human body, or the lobe of a lung. I see a flower and it reminds me of Georgia O'Keeffe.
The work is very erotic but not vulgar. Actually, it's very poetic, along with the colors, salmon, the color of skin. I have never seen anything like it. No other woman artist does anything similar. For example, Eva Hesse made collages using these materials but the shapes and subject matter, the motives were different, and the result was not as physically erotic.

MICHAELA You have a beautiful group of works by Szapocznikow. Do you think there's anything missing?

URSULA Yes, certainly. I would love to have more drawings. In fact, there are a lot of other things—very early sculptures but they are almost unattainable. Museums have become very interested and we loan a lot to exhibitions. I'm too late now. It's just such a pleasure for me to discover a superb piece that may have been in the studio for a long time or that comes from her estate.

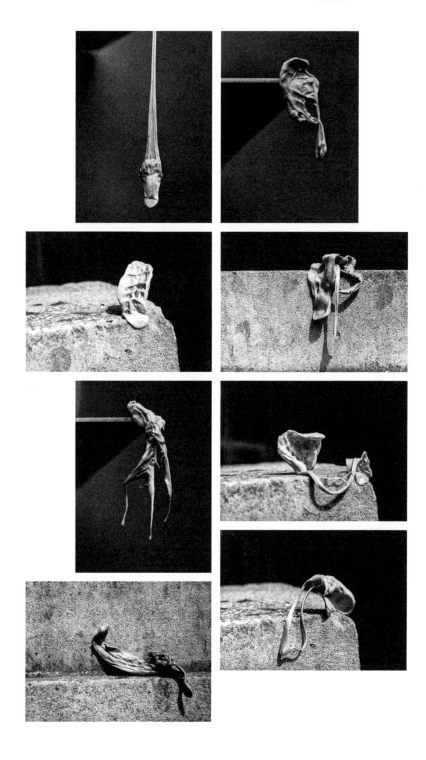

Alina Szapocznikow, *Fotorzeźby* (*Photosculptures*), 1971 / 2007

Carol Rama is another artist I discovered at an art fair. First you buy something and then you find out more about the work and the artist. Where does the artist come from? What has she done? The dealer, Isabella Bortolozzi, was very helpful, very open and informative. I learned a great deal about Carol Rama from her. Sadly, I never met her myself. By the time I discovered Rama, she was already extremely fragile, and she has since died. Even so, I felt an affinity with her. She was a great, resolute woman, and firmly asserted herself. The art that she made was not exactly beautiful, but it was certainly provocative. In Torino, a gallery exhibition of hers was summarily shut down! It was too erotic, too much for Italy.

People wouldn't understand that nowadays. Nobody thinks twice anymore about exposing the body. Carol Rama had a small studio. She produced primarily wall pieces and just a few objets trouvés—like Spoerri and Tinguely, who made assemblages out of materials we would ordinarily throw away. We are living in a throwaway society. At the time, they must've sensed that we were going in that direction. Prosperity doesn't have only positive consequences.

MICHAELA You see something, and it grabs you. And it is not exactly the beauty of a work that triggers something in you. Do you hang these things up at home?

URSULA Yes, as a rule. As soon as it's mine, I want to live with it. I want to study it, appreciate it. Some works soon disappear again, but many stay on my walls forever. Obviously, I'm not looking for decoration. In fact, I'm not really looking at all. Admittedly, I did have the need to devote myself to painting again. Picasso, Picabia, and all these artists of classical modernism—they were givens and hopelessly expensive. I was not about to run after them! I can go to a museum to look at them. But what did interest me, for instance, was that Richard Jackson said, "Painting is over and done with," and Arte Povera

For people of my generation, it was impossible to let on that you were vulnerable. You would never reveal the reflections on your inner mirror. That was a sign of weakness and then you would have been lost.

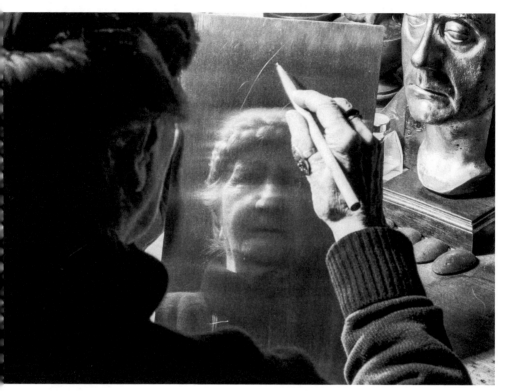

Carol Rama in her studio

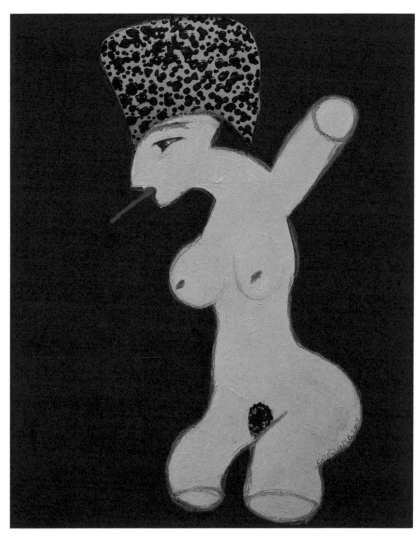

Carol Rama, *Epifania*, 2003

artists who said, "Painting is over and done with." A shocking statement! And the way the artists treated their work! They slashed canvases, scratched them up or worked over them with nails, like Günther Uecker. The 1960s were very important for me although I wasn't active in the arts at the time. As a mother with three small children and a business, I had no opportunity to travel. But these artists always interested me a great deal. They created a new direction in art and declared objective subject matter, figuration, that's over and done with. Giacometti prefigured that with his quirky sculptures, his clunky iron rods.

Responsible for Art

Heidi Bucher

MICHAELA Heidi Bucher works with comparable materials and she also plays an important role in your collection.

URSULA We just toured an exhibition with her sons at Parasol Unit in London. It was curated with such sensitivity. Yes, Heidi Bucher did work with similar materials, but she had different visions. She wanted to preserve traces of her life. She used latex to make casts of her grandmother's house. That's how she created her so-called "skinnings" of front doors and of her studio. She belongs to the same generation as Hesse and Szapocznikow. Artists started working with latex in the 1960s and 1970s.

But Bucher also made wonderful drawings and collages. Once again, very distinctive pieces, consisting of clothing from her supplies that she embalmed in latex. Or her frottage. It reminds me a little of how I was always pressing and drying flowers as a child. Preserving something that you can't let go. I think that's so wonderful.

But my favorite work by Heidi Bucher is the sculpture installed in Parasol Unit's garden, *Die Quelle* (*The Source*, 1987). An incredible piece. And it's a wonderful location for the sculpture! It reminds me of Franz West's pissoir, *Étude de Couleur*. In this case, Bucher incorporated the surroundings into her sculpture.

LAURA The work is a beautiful metaphor for life, as if life were being served, poured. It's lovely the way her sons described it.

URSULA Exactly. And with such simplicity. It produces a eureka effect. So poetic in the landscape, absolutely wonderful. A tree or flowers can produce the same effect. That's what I like about Heidi Bucher. Unfortunately, I don't have this work in my collection. But I'm so pleased that she has finally been discovered; extensive shows are being devoted to her work both here and abroad! Important key works are surfacing again, like what she did with her studio in the cellar of a butcher's store. A skinning of the entrance. You can feel that it goes downstairs and presumably you have to bend down. The skinning is three-dimensional, not flat, and her son said that the windowless space in which Heidi Bucher worked was a small tiled meat cooler. It's fascinating just to look at the skinned entrance and imagine what's happening behind it. It's so fruitful to hear her sons describe how they visited their mother down there. I have *Weissleimhaus* (*Glue House*, 1983) by Bucher. She made four of these houses. The family still have two, I have one, and one is in a private collection in the United States.

MICHAELA Formally, it recalls minimalist sculpture, but at the same time it tells so many stories.

URSULA Yes, it reminds me of the minimalists, Carl Andre, Félix González-Torres. And Eva Hesse also made minimalist works. There are no windows in Heidi Bucher's house, but there isn't a roof either, only an entrance. Her sons describe it very well. Indigo suggests that it corresponds to his mother's ideal of the room in which she wanted to live. Just bare, with nothing specified. You can be totally creative in it. Everyone in their own way, whether musically or literarily. It's really a room that simply challenges you to act. A kind of enlightened action without the confinement of a roof. She made large space-filling objects as well, which were on view, for instance, at the Swiss Institute in New York. Wonderful works. There is still so much to discover in her oeuvre, so much

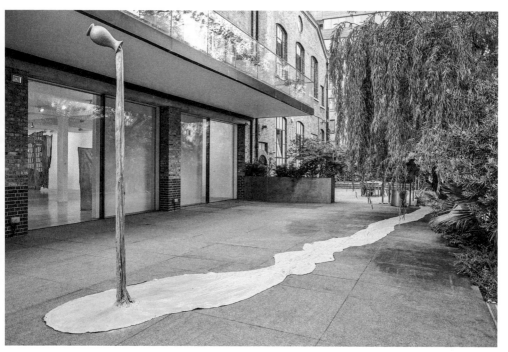

Heidi Bucher, *Die Quelle* (*The Source*), 1987

Mayo and Indigo Bucher with Ursula in the exhibition *Heidi Bucher,*
Parasol Unit, London, 2018

Heidi Bucher, *Weissleimhaus (Glue House)*, 1983

to study. Maybe a catalogue raisonné will be published someday so that people can trace her artistic development step-by-step.

MICHAELA A catalogue raisonné requires a great deal of support from the family, the estate, and the galleries. And of course, there is so much that can get lost. You speak of your encounter with her sons and how much you learned from them about her work that you didn't know before.

URSULA They have to be given a platform or they have to be shown how they can present the work of their mother and share it with the public. They have to learn how to manage the estate sustainably through sales and galleries. An estate costs money! I think it's now important for them to find good backing so that they can administer the estate on a long-term basis.

MICHAELA You have brought up fundamental tasks that all estates have to deal with: management and operations. And, as often as not, it's not galleries or institutions that are handling the estate but rather relatives who are confronted with such issues for the first time.

URSULA Not only that: relatives are generally not so involved in the work or realize only later the importance of what their father, uncle or mother did, more than what other practitioners do. It's a great responsibility and a learning process, especially since you can't just throw an estate on the market. The relatives need a partner, not just exhibition makers but also people who write about it, do research into it, complete biographies, etc. That's really important.

MICHAELA A provocative question: Do you think gender plays a role in the conflict, for instance, between male descendents and an artist mother? I'm thinking of the women in your collection, like Bourgeois, Szapocznikow, Applebroog, and Nicola L., in other words, women who explicitly address issues of femininity in their work. Eroticism also plays a big role. And maybe there are family taboos that get in the way of studying and under-standing the work in its entirety. Maybe there simply isn't that much interest in it or do you think it will grow over time?

Louise Bourgeois with her assistant Jerry Gorovoy
leaving her Brooklyn studio, 1993

Musa Mayer receiving the FILAF D'or for the book *Philip Guston: Nixon Drawings, 1971 & 1975*, International Art Book and Film Festival, 2018

URSULA Children of these outstanding artists often say that their mothers didn't really relate to them. They were self-absorbed, devoted to their work, so that the children sometimes ended up practically negating it: "Mother is constantly doing something and she's never around." Why is that? The children didn't understand. Maybe they didn't want to take a closer look at what their mother was doing because they were often deprived of her attention. So many times I've been told: "My mother was never around, I only saw her occasionally. She was always in her studio and sent me away." Sometimes an artist's life is also nomadic, families have to move a lot, and the artist mother doesn't give her children the comfort and security that is expected of a mother. Only later do their offspring realize that they should study the art a little more and explore memories in order to understand the larger context.

MICHAELA Being a mother also means providing an emotional safety net. But as an artist, you have to get closer to yourself so that you sometimes even find yourself excluding those who are actually closest to you. Family members first have to liberate themselves in order to find access to the work. Are studio assistants possibly better equipped to communicate an oeuvre?

URSULA It's obvious in the case of Louise Bourgeois—Jerry Gorovoy! Jerry was her assistant from the very beginning. He was a support in every respect and is actually also an artist himself. And of course, children do not automatically inherit the tendencies or talents of their parents. In Bourgeois's case, for example, one of her sons is a physician, another a philosopher, a thinker, and the third died at a very early age. Children of artists may have no interest in art whatsoever.

LAURA It makes you wonder whether it's more problematic for children of women artists.

URSULA It's not easy. Of course, this has to do with a woman's image—that was different in the old days; she belonged at the stove. A woman must devote herself to the family, and not make art, putter around, or worse, do something independent.

Men leave the house, they go to the studio, to the workshop—
it's all perfectly okay—and come home late because they have
to finish something up.
But it is also often not easy for the children of male artists.
Great artists are simply obsessed with their work!
I am thinking of Philip Guston and his daughter Musa. I
thought for a long time that Musa, his only daughter, was very
close to her father. I thought she had a sheltered life and spent
a great deal of time in his studio. But that was not the case!
Musa wrote a wonderful book about her father, *Night Studio*.
It's a touching memoir in which she describes that for her
father, painting was everything. "Painting is my life," he once
said. Only afterward came family. She had to learn early that
she wasn't allowed to disturb her father and she suffered greatly
from that neglect. Only after his death, did she begin to study
her father's life and work. Today, she is a great communicator
of his work, and devotes herself with incredible energy to the
Guston Foundation, the publication of her father's catalogues
raisonnés, and even curates exhibitions!

Lee Lozano

URSULA And in some cases, it's not the relatives but galleries
or friends who take responsibility for an estate. For example,
Lee Lozano, who had no descendents.
Lee Lozano was a discovery for me. Barry Rosen, who also
acts as the advisor for the Eva Hesse Estate, and Jaap van Liere
drew my attention to her work and her 2004 exhibition at PS1
in New York. As you know, I'm always looking for painting,
and I studied Lozano's life and work with great intensity.
The first time we reviewed her work in depth was after we had
received boxes and boxes of material. We had spread everything
out in our depot and slowly began working our way through
it. It didn't take long to realize that this oeuvre clearly deserved
to be preserved, inventoried, restored, and researched. I now

Lee Lozano, 1963

Lee Lozano, *No title*, 1963

have a marvelous group of works in my collection, many of which are hanging here at home. It's an important oeuvre and to me, Lozano is on a par with women artists, like Roni Horn.

The Omnipresent Eye

Maria Lassnig

MICHAELA One can tell how much you regret that, in some cases, when you come across artists you would like to collect, you are deprived of ever meeting them personally.

URSULA Yes, in Carol Rama's case, I was too late. But I have still been able to meet a number of artists. I had good contact with Maria Lassnig and often went to visit her, in fact, until shortly before she died. She was such a praiseworthy painter!

LAURA You have quite a number of her works covering all phases of her career, the earliest from 1954 and the latest ones from 2010. *Die rasende Grossmutter* (*The Racing Grandmother*) of 1963 is an extremely important work in your collection.

URSULA 1963 is the year my daughter Manuela was born. That was when Maria began doing figurative work again. Before that, actually since studying at the Art Academy, she had been trying to find ways to make her painting more abstract. What impresses me in her work, time and again, is the eye. In practically every painting, you see a blue eye, like a telescope. It's always as if you were being addressed, controlled. You can really feel her, you can really get intimate with her. Always her eye. It always comes toward you, this eye. She was so alert up to the very end. Always interested.

I have a wonderfully broad selection of her oeuvre. There are a few works of the 1960s that are still missing. I would love to have *Napoleon und die Brigitte Bardot* (*Napoleon and Brigitte Bardot,* 1961), but I'm afraid that's not going to happen anytime soon. I'm patiently hoping for the Lassnig Foundation to say one day: "Enough, we need money!" It was extremely

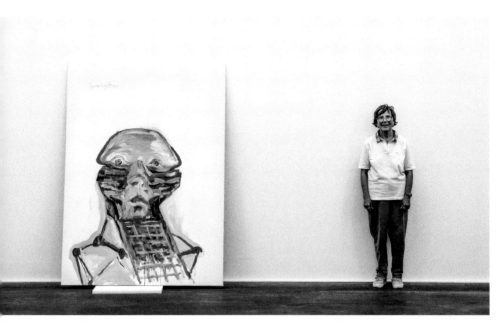

Maria Lassnig with *Sprachgitter* (*Language Mesh*), 1999, during the installation
of *Maria Lassnig: A Painting Survey,* Hauser & Wirth Zürich, 2007

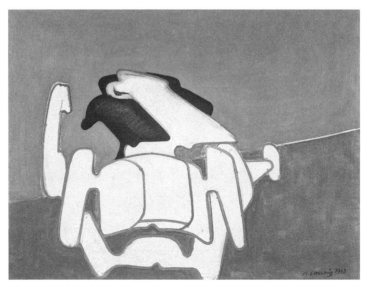

Maria Lassnig, *Die rasende Grossmutter*
(*The Racing Grandmother*), 1963

Maria Lassnig, *Augenmensch*
(*Eye Person*), 1992

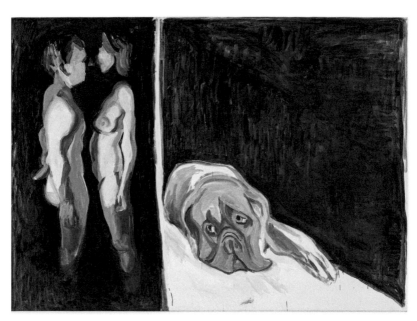

Maria Lassnig, *Mann, Frau und Hund*
(*Man, Woman, and Dog*), 2010

hard to acquire a work from Maria. Very hard. Sometimes she would say yes, sometimes no. Then, hardly had we come to an agreement when she would retract everything again a few days later. And then agree after all. "But don't you ever pass the painting on. If you do, we won't be friends anymore!" Maria was a doyenne. I met her fifteen years ago. Florian Berktold told me about her. Florian sometimes comes by with a book and says: "This is still missing from your collection." Then, I immediately start gathering all the information and study the biography. People's life stories are my favorite form of literature anyway. And then I had the opportunity to visit Maria Lassnig. There are important elements that keep reappearing in all of her works and self-portraits. She described herself as an ugly duckling, ignored, misunderstood, unloved. High cheekbones, big teeth, the eye. Those are three elements that keep popping up in her paintings. The body, the nudity, unflattering, which is exactly what makes her work so contemporary!

MICHAELA The body not pictured as a status symbol, an outer shell, but rather as the expression of something behind the represen-tation, lying under the skin.

URSULA Exactly. This painting shows her as a voyeur, young lovers, something she never had. She had several affairs, including an affair with Arnulf Rainer that lasted five years. You might say she was looking for sparring partners—somehow using them to come to terms with her own doubts and fears. And she always had a troubled relationship with mother. They were strapped for money. Then, her mother married the owner of a bakery and Maria was able to take private drawing lessons. So her talent was recognized at an early stage although it was almost impossible in those days for a young woman to become an artist. That's why she first trained as a primary school teacher, only later applying to the Art Academy. There, she found encouragement and received several stipends. Her pain and disaffection with society are so clearly expressed in her drawings and pictures. That made a huge impression on me.

I feel privileged to have a lot of her important works in my collection and to be able to support many exhibitions by loaning them out. It's a privilege to have the opportunity to acquire something, especially when the artist approves the purchase. And then, naturally, I also feel obliged to show the works to the public. Actually, more than obliged, because it is such a great pleasure to share them with others. And even more so, if it's a good institution. Then, it is also reproduced in a catalog, and in that way, the work is not simply on loan for one, two, or three months, but also inscribed in the history of the institution.

Poetry and Beauty

Berlinde De Bruyckere

URSULA Manuela and I discovered Berlinde in the International Pavilion at the Venice Biennale in 2003. We were mesmerized by *Hanne, 2003* (2003), a sculpture with hair covering the face. Manuela contacted Berlinde and we often visited her at her studio in Ghent. We have since become friends.

LAURA Are there favorite works of Berlinde's in your collection? What is it in her work that appeals to you so much?

URSULA The horse *Eén, 2003–2004* (2003–04) is actually the ultimate sculpture for me! A horse can be carved in stone, but a horse made of horse skin? Skin is living material and I was fascinated by the way Berlinde works with such different, new materials. Or the way she chooses the pedestals herself, like an old butcher's block, and combines them with sculptures.

MICHAELA Berlinde doesn't make easy work and there's often something quite unsettling about it.

URSULA Yes, it's about age and death. That takes courage, for me as a collector as well. There aren't many viewers who appreciate it—a dead horse on a pedestal? That's challenging. But I find it extremely poetic. Like Berlinde's exhibitions, which always relate to the sacred, for example, the exhibition *Mysterium Leib*

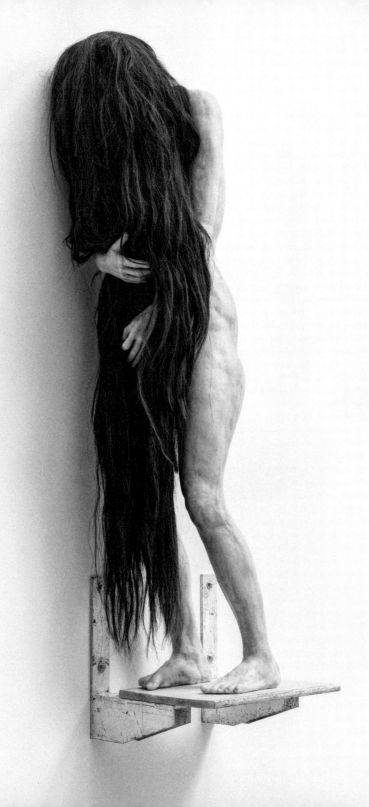

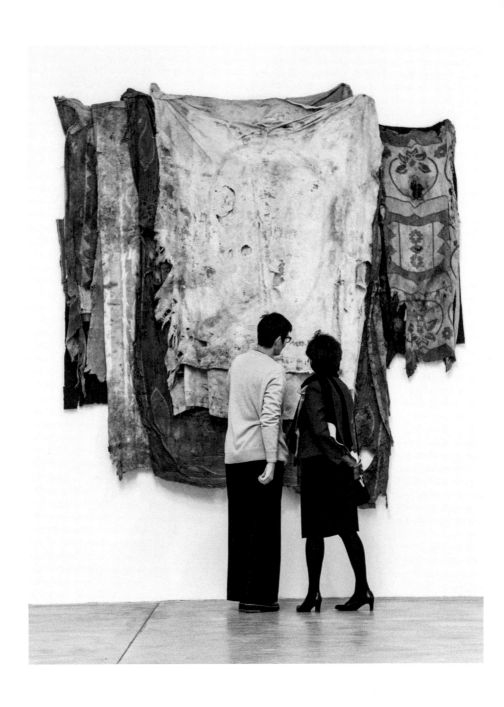

Berlinde De Bruyckere and Ursula by *Courtyard tales, 2017–2018*

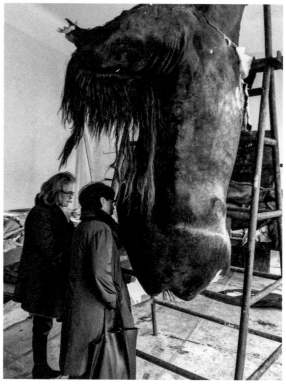

Tilla Theus and Ursula in Berlinde De Bruyckere's studio, Ghent, 2015

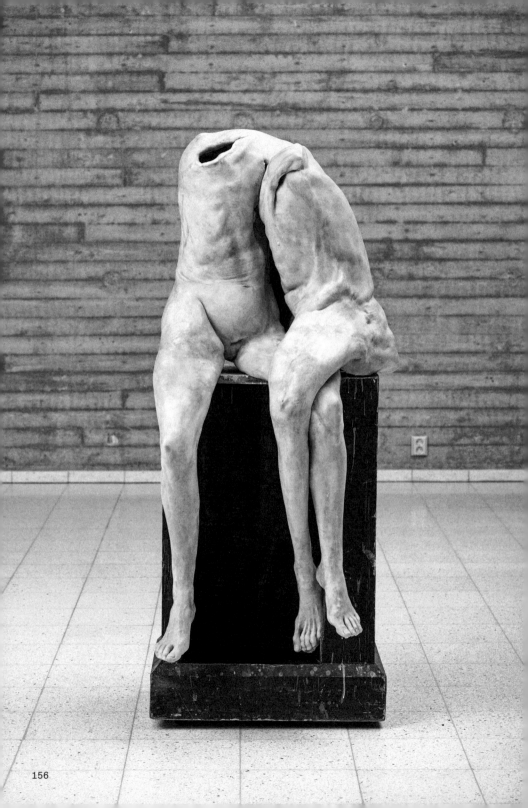

at the Kunstmuseum in Bern, or the *Piëta, 2008* (2008). Berlinde is not out to please. On the contrary! She provokes viewers. She doesn't give the sculptures an identity, and she deprives the body of its individuality. As a rule, the head is hidden or merely hinted at. I associate something beautiful with these disfigured, morbid bodies. She makes them herself, and the way she prepares the wax surfaces is very beautiful. The bodies are beautiful. Viewers are startled at first, but if you have ever accompanied a family member in old age, you can see the beauty. They make you want to touch them. Even so, a lot of people are put off by them and tend to look away.

LAURA We've noticed in exhibitions that it's mostly men who look away; they want nothing to do with the sculptures.

URSULA Exactly! They leave again very quickly, for example, when they see the *Piëta,* the two figures on a pedestal. I try to explain my thoughts or feelings about the work, but I am often met with incomprehension. To me the work is poetic.

MICHAELA The way people approach art is highly subjective, personal, and it's influenced by what they have experienced.

URSULA Yes, life also comes to an end. You have to face it. I think one should accompany people in old age, not only in the good times but at the end of life as well. One of the sculptures that I find crucial is Berlinde's *Schmerzensmann IV, 2006* (2006), including the drawings that go with it. They are wonderful works!

MICHAELA Were you able to see the entire group in the making when you visited her studio? The drawings related to *Schmerzensmann IV, 2006,* which are now in your collection, once again testify to your interest in the act of creation, the process of making art.

URSULA The way Berlinde renders the material of the sculpture, the many layers and transparency of the skin, in her drawings is simply superb. She does that when she works a sculpture in wax, and she does the same thing in the drawing. And she has found a new way to present sculpture. She has a large

store of utensils left over from estates, of rusty building parts from historical buildings that were torn down. She uses these as pedestals. The post to which the *Schmerzensmann* is clinging comes from an old railroad station. The post already has a history and naturally, so does the figure itself.

The Pursuit of Art!

MICHAELA You and Berlinde have already been friends for over fifteen years and you visit her regularly in Ghent. Does your view of a country change through your encounters with the artists that you collect? And do those encounters lead to new ones?

URSULA Belgium has always fascinated me, I have often traveled to Ghent, Brussels, Antwerp, and I have Belgian artists in my collection. The country has great potential when it comes to artists! We also discovered quite a few things visiting collectors—like works by Agnes Martin and Raoul De Keyser in the corner of an elderly woman's living room! The Belgians were active collectors in the 1960s and had the opportunity to buy important works at low prices. I also met and visited other collectors on my travels, as in Belgium. Some of them installed their collections in old, abandoned sheds or textile factories and lived with the art in that way. Their approach inspired me. In 2005, I set up spaces of my own to present and exhibit my collection.

I still do a lot of traveling, naturally with my partner André, and also with my children and grandchildren.

André has an architectural background, garden architecture in particular. He is more aesthetically oriented and less interested in art history. He goes everywhere with me, to all of the museums, the way I accompany him to all of the botanical gardens, the beautiful ones and the not so beautiful ones. [Laughs] I have learned an awful lot about botany! Gardens, architecture, art—they are all interwoven. Both André and I focus on beautiful worlds.

Ursula with Iwan Wirth, Shanghai, 2007

Mark Bradford in his studio with Ursula Hauser
and André Remund, Los Angeles, 2016

Ursula with her grandchildren in Spain, 2014

When we are in a city with the family, art is naturally the order of the day: galleries and museums. Whether small children, bigger ones, or relatives, everyone has to come along. Afterward, they can pursue their regular program. [Laughs] No matter where we are, in Europe, the United States, or even in Delhi or Hong Kong, we always track down the art. My family in Vienna, Sandra, Rainer, and the children, are equally interested. There are wonderful museums in Vienna, a lot of good exhibitions, and when I'm there, the whole family comes along.

MICHAELA Do any of your children and grandchildren have a comparable passion for collecting? Who will carry on your passion?

URSULA They all collect on a small scale. Besides, instead of giving jewelry or clothing, I prefer to give a work of art. My grandchildren have always been given small art gifts, editions, a print, or a lithograph. So they are surrounded by art at home, too. Some of them hang the work up and live with it, others leave it standing around somewhere. It doesn't speak to them but that doesn't disappoint me. Passions are not something you inherit. My son Urs and his wife Astrid are more interested in architecture. They're not collectors, but they feel comfortable with the art and cultivate a similar style in their home. I don't necessarily see a collector in our family other than Manuela, who is deeply devoted to art.

MICHAELA Do you ever consider making permanent loans?

URSULA Not at the moment. Occasionally, though, I might think of making a gift. Permanent loans actually mean giving something away step-by-step that's never going to come back. So I might just as well give it away properly. It's just that the right moment hasn't come yet [laughs], but at some point things will go in that direction. It's on my mind, but no definite decisions have been made yet about who, what, where, how.

Discoveries in the Artist's Studio

Ida Applebroog

MICHAELA Is there any sort of ritual when you visit an artist's studio for the first time?

URSULA I've always been around artists, when I was young and in the clique in St. Gallen. Most of the artists in my part of Switzerland had a studio. You would just stop by, knock on the door, have a cup of coffee, go through the works, and usually end up having a fun evening. Actually, it was like that in the big American studios, too. You make contact, introduce yourself, or maybe you've bought a work, so there's already a connection. And then you take a very tentative approach, proceed step-by-step, depending on whether the chemistry is there. As a rule, you've already met at an exhibition, in a gallery, or in a museum. And finally you peer into all the corners. It was like that with Ida Applebroog. We found these beautiful drawings in her drawers. Ida didn't mind. You don't ordinarily rummage around in every nook and cranny but Ida was very welcoming and later we were eventually able to buy some of these vagina drawings (*Group C, 1969*). Wonderful, very personal works! However, some artists are much more reserved.

MICHAELA You describe your visit with Ida as carefully feeling your way, giving the artist time to develop a kind of trust, and the confidence to show the work.

URSULA Yes. The person, the artist, always comes first. Always. And then maybe they open up and show me what they're working on. Older artists usually have a huge store of work and maybe they will show you something you haven't seen before.

LAURA What was it like when you visited Ida Applebroog's studio?

URSULA We had already acquired our first work and then went to the studio with Barry Rosen. We simply felt our way very carefully. The latest works, the ones she had just begun, were hanging on the wall. And naturally, I wanted to know more

Ida Applebroog and Barry Rosen, 2016

Clockwise from left: Ida Applebroog, *Group C, #3, #4, #5, #13, #11,* and *#10,* 1969

about her, where she comes from and what her life is like. We also spoke about her family and what it was like to be a mother and an artist. So the conversation became more personal. And suddenly, Ida said, "I have something." We had heard beforehand that she destroyed a number of works. Works she didn't like or that were too reminiscent of other artists, like Eva Hesse or Louise Bourgeois. Naturally, we talked about that as well, and then suddenly her early works on paper appeared. Presumably there is still quite a lot in her archives.

MICHAELA Ida's work focuses not only on larger social issues but also intensely on being a woman and mother, concerns that are of crucial significance in your collection. How does she sense that you have a sympathetic ear? Does she know what else you have in your collection?

URSULA Maybe she feels it in the way one approaches her work. Maybe she feels that somebody understands her. We have common ground. And then suddenly the atmosphere is completely relaxed. As a collector, I'm interested in the entire breadth of her oeuvre. She has done so much in her lifetime. I would like to have a larger range of her work in my collection. Like Louise Bourgeois. I am still buying drawings, early drawings, to supplement the body of work that I have so far. Or in the case of Phyllida Barlow, who didn't just paint and draw, but also made collages. What appeals to me in particular about Ida's work is her materials, the beautiful papers and the parchment.

With Ida and other women artists, you can feel the clear focus, the goal-oriented nature of their work. Ida is no longer very mobile, she's almost ninety years old, she can't travel anymore, and her life is restricted. But she's still into big projects. Her perseverance, her strength has always fascinated me.

URSULA Phyllida Barlow is another good example. She's a little younger than I am and always made art alongside all the demands of raising five children, gigantic installations on a small budget. Her entire oeuvre radiates the incredible strength, the ideas and creativity, that went into making works with whatever she could. She had no financial backing. It's always the same issue. Women have no platform. But they have the unwavering drive to keep going and keep working. She is an independent artist. It is unlike anything anyone else has ever done. Everything comes from her and it is vital to preserve the works, even if the materials have no value.

MICHAELA Much of Phyllida's early sculptural output has not survived; the works were destroyed after they were exhibited. The appreciation of her work has since changed. It is now being conserved and carefully stored. That is also something you've achieved through your collection.

URSULA Originally, I came across Phyllida's works on paper. I bought everything I could that was available on the market. I simply wanted to have it. It was a new perspective that was missing in my collection. It's cheerful in a very special way and at the same time down-to-earth and serious. The works look arbitrary at first sight; but in the studio you realize how carefully everything is planned. She has a clear strategy and is extremely conscientious and exact. In the same way that she always had to plan her life.

Alongside her job as a mother—like I said, she raised five children—she also taught at the Slade School of Fine Arts in London and mostly worked on her art at night. I have early drawings from the 1960s that are 100 percent finished and self-contained. In between, when she had her children, family life naturally took precedence and she did not spend as much time on her art. You can see that a few years are also missing in my collection. I was so surprised when the drawings of the sixties cropped up. They are marvelous!

The person, the artist, always comes first. Always.

Ursula, Phyllida Barlow, and Fabian Peake, 2012

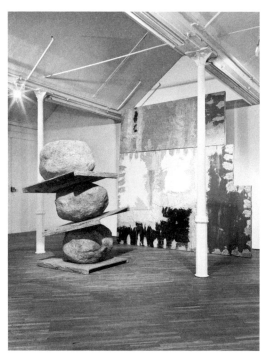

Phyllida Barlow, *untitled: stack*, 2015

Phyllida Barlow, *untitled: awnings 4 (yellow)*, 2013

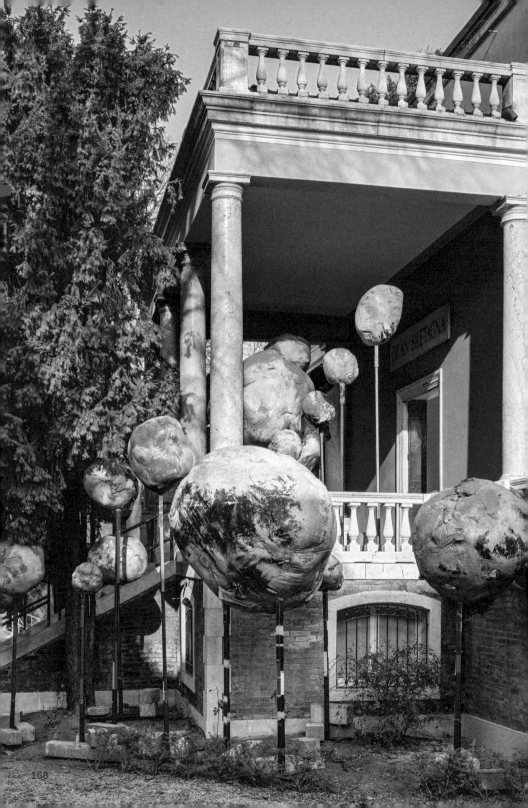

MICHAELA Phyllida represented Great Britain at the Venice Biennale in 2017. How did you feel about her presentation at the national pavilion?

URSULA Full of pride and joy for the artist! I felt that I was a part of it, in the shadows, of course! She has created something so extraordinarily new and different, incredibly young and contemporary! Even though we are of the same generation! I am so very proud of her and delighted with her success.

LAURA In a sense, it is your doing as well inasmuch as you collect with the thought of giving women artists opportunities and space.

URSULA Yes, absolutely. But it was different with Phyllida. She came to the gallery and we were able to introduce her to good locations and museums. The works in the collection also "profited" indirectly, increasing in value, though admittedly in small increments.

Phyllida Barlow: folly, British Pavilion,
57th Venice Biennale, Italy, 2017

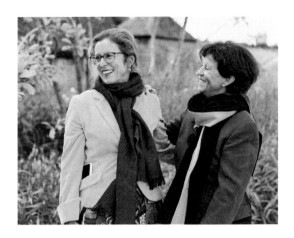

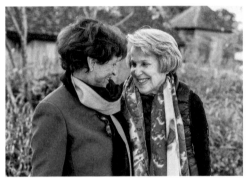

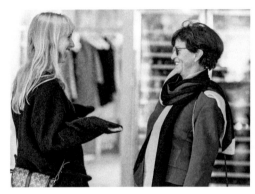

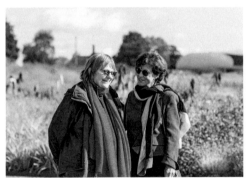

Clockwise from top: Ursula with Manuela Wirth; Anj Smith; Bharti Kher;
Phyllida Barlow; and Helen Charash, Somerset, 2018

Strong Women

MICHAELA You often speak about "the women in my collection." For women artists, you are a mentor, someone who understands them and shows solidarity. Many of the women, whose work you have collected, were also active feminists. How do you view this aspect in your collection?

URSULA I was never a feminist. Maybe I should've been more courageous, maybe there are times when I had reason to be, but I never felt the pressure to move in that direction. Although, when I think about the 1960s and 1970s and about certain women artists, I certainly do understand the agenda of the feminist scene, especially in New York. Women artists like Nicola L., Eva Hesse, Sylvia Sleigh, Judy Bernstein, and many others were very active in the 1970s, took a stand against the male-dominated art world, and resolutely challenged the representatives of art, galleries, and museums. I personally never felt the need to take a feminist stand.

MICHAELA On the other hand, you were very well aware of what it takes for a woman artist to assert herself, the perseverance she needs to pursue her artistic goals, in addition to all of her other obligations. And time and again, you have created platforms for women, which is actually a natural form of feminism without explicitly saying so.

URSULA Yes, that's true, and without being provocative. I could never be a politician either, impossible. I certainly have a point of view, but I don't want to be in the position of having to propagate it in public. I have always been deeply impressed by the way women carve a place for themselves. Meret Oppenheim once said that freedom is not given to you, you have to take it. And also that women have the obligation to prove that the traditional image of women no longer applies. I simply have the need to support women artists and open up paths for them to the best of my ability.

MICHAELA What is it that appeals to you in art? What touches you and what makes you want to show it?

URSULA As a collector, I want to live with things that inspire and energize me, that give me pleasure. I want to have them around me. You can tell that a lot of the works in my collection have been made by women because of the vision and sensitivity in dealing with materials. And, of course, the subject matter. All that appeals to me more than machine constructions. That's why I'm not so interested in photography. I see the subject matter and I see a lot of good photographs, but I don't see the artistry behind them, the handicraft itself. With a lot of artists, you sense a particular approach regardless of the medium.

The Expanded Living Room

MICHAELA You have set up private spaces to view and exhibit your collection in an old factory not far from where you live. What led you to do that?

URSULA The spaces couldn't be more suitable. The administration of the collection is located there, and the context is just right. Actually, it keeps me here in eastern Switzerland although none of the other members of my family live here anymore. I have a professional team that manages and administers the collection, and the exchange with my three coworkers, Laura, Angelika, and Sarah, is an invaluable part of the whole! Without them it would be absolutely impossible for me to manage everything in this form. The administration of loans, insurance, transport, assessments, and the handling as a whole is a huge amount of work. The collection has now grown to over one thousand works, so operations are understandably complex.

MICHAELA Once or twice a year, you mount a large exhibition in your showrooms. How do you proceed?

URSULA Each year, the focus is usually a major piece that I haven't seen for a long time. That's the springboard for taking a closer look at what I've actually accumulated over the years. In 2018, it was Richard Jackson's installation *1000 Clocks.* And I felt it

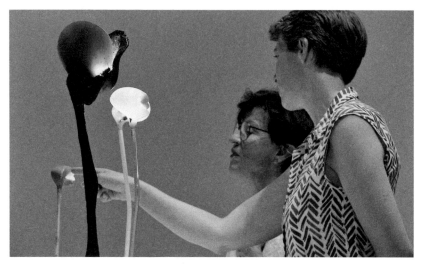

Ursula and Laura Bechter visiting the exhibition *Alina Szapocznikow – Human Landscapes,* Staatliche Kunsthalle Baden-Baden, 2018

Carmen Reichmuth and Sarah Lili Frey during a 2019 condition check of Meret Oppenheim, *Pelzhandschuhe (Fur Gloves with Wooden Fingers)*, 1936

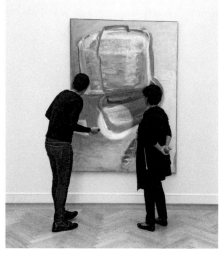

Angelika Felder and Ursula during a condition check of Maria Lassnig, *Lichtkoffer* (*Lightcase*), 1993, Kunstmuseum St. Gallen, 2018

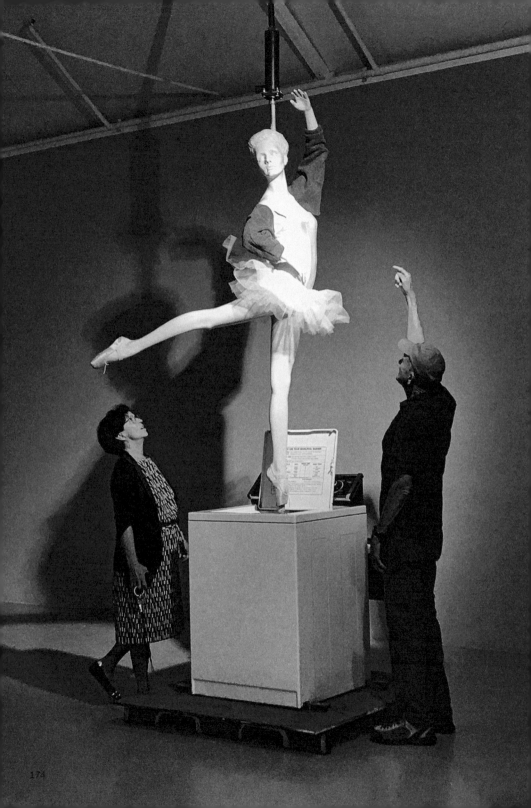

was important to be able to give my long-term employee Roland Remund the opportunity to install the work one more time, because he has been working for us for more than twenty years and will soon retire. Once we've chosen the piece, Laura goes through the inventory of the collection and makes suggestions for the exhibition.

LAURA And that leads to intense debate. An exciting and fruitful process.

URSULA Starting with Richard's *1000 Clocks,* we selected additional work by him, along with work by two other West Coast artists, Jason Rhoades and Raymond Pettibon. Those are all friends and part of the family! And we complemented it with younger practitioners, like Rashid Johnson and Matthew Day Jackson. The exhibition we mounted the year before last highlighted women artists in the collection. We started with Louise Bourgeois's *Spider* and put it in the context of the cells, the drawings, the paintings, and some of her other sculptures. I keep thinking we've run out of themes, but Laura always manages to come up with something. [Laughs]

Richard Jackson

MICHAELA You've traced Richard Jackson's work for over twenty-five years. Which works are especially important to you?

URSULA *1000 Clocks* is one of his biggest and certainly one of his most important works. But I also have a weakness for his paint actions, his *Wall Paintings.* And then the beautiful drawings! I have works in several media: drawings, neon, and sculptures.

MICHAELA Painting is a dominant theme in Richard's work; he paints but with other means.

URSULA He announced that painting was finished and promptly found another way of doing it, another context for it. It's always a pleasure to visit him in his studio in Los Angeles. It's so exciting. Or he comes to see us. He was here again just a few months ago. My door is always open.

Richard Jackson explains the mechanics
of *Ballerina in a Whirlpool,* 1997/2018

Richard Jackson, 2014

Ursula with Richard Jackson in *1000 Clocks*, 1987–92,
Ursula Hauser Collection, Switzerland, 2018

Loredana Sperini, 2017

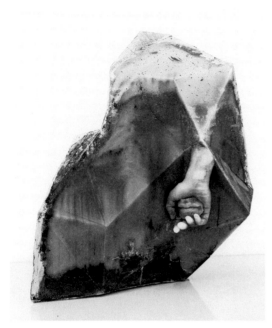

Loredana Sperini, *Untitled*, 2012

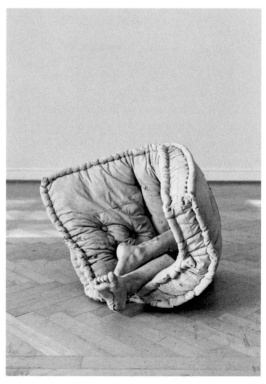

Loredana Sperini, *Untitled*, 2016

Zeng Fanzhi recently came to visit. We couldn't say a single word to each other. He doesn't speak English, only Mandarin. That was quite a challenge. But somehow it worked anyway, and we felt close to each other! He sat here at the kitchen table. I hosted him, cooked for him; he ate and obviously enjoyed it, as if he was at home here!

MICHAELA You have also installed a screening room in your private showrooms, in which you occasionally show the work of younger artists.

URSULA We used it recently to host a solo presentation of work by Loredana Sperini. Actually it was Manuela who discovered Loredana. Then I started collecting her, too, and went to her studio several times. When she makes something new, I try to acquire a piece in order to have a larger group of works in my collection, sometimes bulky works as well. I really like the sculptures, the way she uses concrete and manages to make it look so light: an old mattress cast in wax and cement or a window. Loredana is a slender, graceful person. Some of the small figures are broken found pieces that she unearths at flea markets in Berlin. She reassembles them, places these mini sculptures on a mirror, and enlarges them with light. It's surrealist somehow. Maybe that's why they appeal to me.

MICHAELA Your private showrooms are like an extended living room, somewhat like an open house, a kind of semi-public space accessible to an interested public.

URSULA Yes, a lot of visitors come, curators and friends from museums. We provide a platform that is like a gallery, except that we don't sell anything. We give artists space, we present them, and occasionally that may lead to something bigger. Following our presentation of Loredana's work, the Kunstmuseum St. Gallen invited her to have a solo exhibition. It was absolutely great!

LAURA When we plan an exhibition in the showrooms, we deliberately choose artists who are not so well-known and then offer tours to introduce them to visitors.

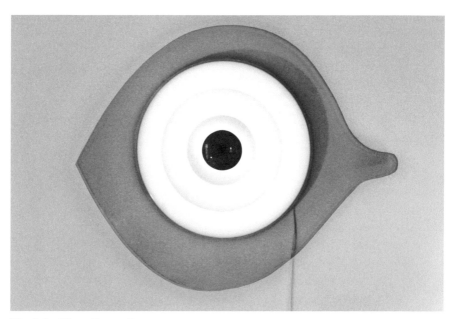

Nicola L., *Planet Eye,* 1968–2014

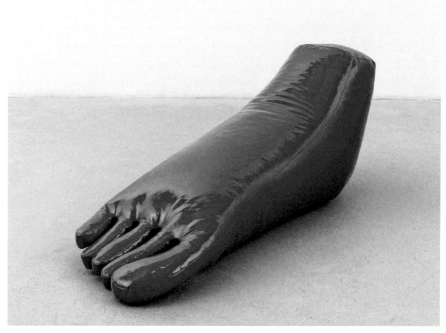

Nicola L., *Foot Sofa,* 1968

Nicola L.

URSULA For example, Nicola L. We showed her work a few years ago. The museum trustees from New York had never heard of her, even though she lived and worked there for decades. She was over eighty when she died. She was not in the public eye and hardly ever shown. But more often than not, she was the one who opted out or acted up when someone wanted to do something. Her New York dealer, Anke Kempkes, was a wonderful advocate of her work but finally gave up. Nicola L. was in bad health and could no longer actively participate in exhibition projects. Her work has tremendous potential and should really be in a museum. At this point, however, you would first have to invest in making an inventory in order to approach museums. Unfortunately, I had lost touch with her, but she plays an indispensable role among the women artists in my collection. Her works are cornerstones, a crucial part of the whole.

MICHAELA How did your contact with her come about?

URSULA Nicola L. is originally from France. She lived in New York's Chelsea Hotel for years. All kinds of artists, filmmakers, and actors frequented the hotel for decades; they had apartments and studios there. In the meantime, the hotel has been renovated but it was pretty run down in the 1980s. Nicola L. had the lifelong right to live there and was able to return after it had been renovated. But she came down with Alzheimer's and went to live with her son in California.
I originally noticed her at FIAC in Paris. The first work I acquired is *Giant Woman Sofa* (1970/2012), a real sofa of vinyl with twelve separate elements—legs, arms, breasts, etc.—that can be used as cushions. Oversized, a good ten feet long. She made a partner piece as a man. And because I'm always curious, I wanted to know what else she makes, where she works, and so on. I often visited her in New York.
She was a demanding artist and changed her gallery several times.

Artists and galleries should be a team. Artists are rarely good at selling their own work. Or they sell it to the wrong people. They need someone to negotiate for them. The galleries do the work and should be paid for it.

Nicola L. organized actions in public, like *The Red Coat: Same Skin for Everyone* (1969–92). She had a group of people walk down the street and make music under a single raincoat that she had sewn. The main person was a clarinetist, who headed up the group.

She is such a wonderful artist; she has broken new ground with her idiosyncratic works. Even though they were hard to communicate or sell, she kept on working. I was most interested in her furniture objects, like the work of Franz West. She also made a *Foot Sofa* (1968) that you can actually use, like her lamps, objects that are functional and with which you can live.

Sylvia Sleigh

MICHAELA The word "painting" has cropped up repeatedly in the course of our conversation.

URSULA Yes. Although I have quite a number of objects and sculptures in my collection, I had the feeling in the years after 2000 that I miss painting! I discovered Sylvia Sleigh through a young dealer. Sleigh struck me because she is a good painter. And as usual, if the artist is still alive, I want to make her acquaintance and become familiar with the context in which the work is created.

Sylvia, a native of England, first moved to Bennington and later to New York in the early 1960s. Her subject matter is primarily portraits and also nudes. The male nudes don't appeal to me so much, but I'm interested in the female nudes and the richly detailed patterns in her paintings. Sometimes it's a little too figurative or even kitschy and it doesn't echo the zeitgeist in New York at the time. And yet it is abstract at the same time. In fact, I see a lot of references to abstraction. Mostly she

Ursula during the renovation of Sylvia Sleigh's house, New York, 2014

Sylvia Sleigh in her home, 20th Street, New York 185

Sylvia Sleigh, *Working at Home*, 1969

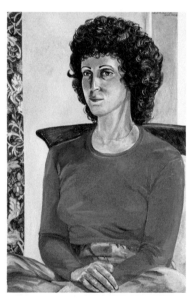

Sylvia Sleigh, *Diana Kurz*, 1978

portrayed friends of hers. I have even met a few of them in the meantime. They have white hair now, too. She also painted a lot of portraits of herself at home.

We became friends in the course of my visits to New York. We hit it off instantly. There are photographs of us on her sofa. She was already over ninety years old, lived on 20th Street, directly opposite Louise Bourgeois, and had no children. Louise and Sylvia were acquainted. Friendship is relatively rare among women artists. But they knew each other well because Sylvia took part in the women's movement in the 1970s. Sadly, we did not know each other long. I would have loved to go with her to a pastry shop and simply listen to what she had to say. She was an extremely beautiful old woman.

LAURA Sleigh was married to the curator Lawrence Alloway and actively involved in the New York art scene during those years.

MICHAELA Louise Bourgeois was also married to an art historian, Robert Goldwater.

URSULA Yes, that's right, men used to woo young women artists in those days.

LAURA *Working at Home* (1969) is the first work you acquired by Sleigh. It pictures the artist in her house, painting at an easel with her husband Lawrence sitting at a desk in the background.

URSULA She didn't have a studio, she always painted at home. The background of her pictures usually shows the flowered wallpaper in her house. After Sylvia died, I was able to buy the house and tried to reconstruct everything. The house was in terrible condition because she hadn't invested in it, hadn't had any work done on it for a long time. We reconstructed some of it, the decorative molding and the architecture of the ceiling, and we even found the same wallpaper. We restored the mirror in which she portrayed herself in *Working at Home* and put it back up in the same spot where it was hanging when she did the painting. Out of respect. In memory of her, you might say. Douglas Jones, who was Sylvia's longtime assistant, told me how fond she was of me and would surely have been pleased to know I had taken over the house.

There's another painting, *Three Women (for cover of Time Magazine)* (1972), that I think embodies Sylvia Sleigh. I have it hanging in a prominent position at home. As the title states, it was a draft for the cover of *Time* magazine and pictures her with two other women. Douglas looked after her up to the end, much like Jerry Gorovoy cared for Louise Bourgeois until she took her last breath. Douglas was familiar with the house and Sylvia's habits and used to take her to the theater. He organized everything for her and now he does that for me as well. He knows a lot of stories about the people who came and went here and what they did. I want to keep the spirit of this house alive— in my own way, of course.

Going Public II: Kunstmuseum St. Gallen

LAURA When did the moment come, when you said to yourself: I am an art collector?

URSULA That's something I have never thought: I am a collector. Never. [Laughs] I was never conscious of all the things I was accumulating and buying. But now institutions approach me, asking for loans, and I've come to realize that I have an important contribution to make to the history of art. I am a collector.

MICHAELA You support institutions by lending works, and you show parts of the collection in public exhibitions. The Ursula Hauser Collection has been cooperating with the Kunstmuseum St. Gallen for several years. How did that come about?

URSULA To begin with, I come from St. Gallen. I've noticed that for a lot of people, Switzerland ends after Zurich and Winterthur. St. Gallen is a forgotten corner somehow, especially culturally. Except for the municipal theater, which is very active and has the funding to cultivate the zeitgeist. In contrast, the art museum is not well-financed even though the director Roland Wäspe and his team are internationally active and mount impressive exhibitions. So why should I support a

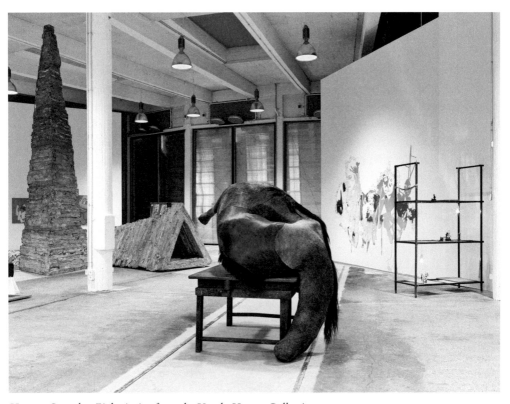

Human Capsules: Eight Artists from the Ursula Hauser Collection,
exhibition view, Lokremise, St. Gallen, 2012

different museum that already has major holdings? I would rather do something in my home territory. After we left St. Gallen, the museum's department for young art moved into the Lokremise. But the city was not prepared to continue funding the program. Naturally, that would have been a terrible loss. That had to be prevented! So I agreed to do one large exhibition a year at the Lokremise for the next three years.

LAURA The museum budget only covered running expenses, but had no funds allocated to finance borrowing works of art.

URSULA Visitor numbers are low in eastern Switzerland. There are simply fewer people living here. People from all over the world come to Zurich when Art Basel is on, but not many come to St. Gallen. That was a disappointment for us when we were running the Hauser & Wirth Collection in the Lokremise. Nonetheless, it's important for these institutions to survive. The Kunstmuseum is a marvelous venue, it's such an experience!

MICHAELA Was that also a motivation for donating Roman Signer's drawings and installations to the Kunstmuseum?

URSULA Roman's project drawings complement the collection of the Kunstmuseum. As sketches for his actions, they are revealing and informative, especially since he did not implement all the ideas that he sketched.

I want to decide myself, while I'm still alive, where something goes and Roman's eightieth birthday was a good occasion. St. Gallen is my expanded living room. I love the museum! And that's where Roman belongs. He comes from St. Gallen, and so do I. It's like coming home again, like coming back to your roots.

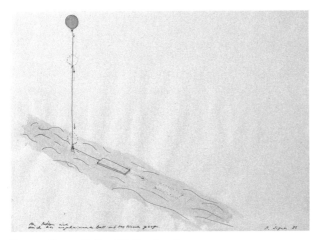

Roman Signer, *Ballon (Balloon)*, 1982

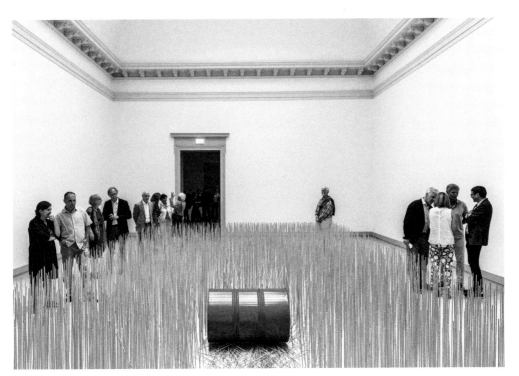

Roman Signer, *Blaues Fass: Schneise im Feld (Blue Barrel: Field Row)*, 1999/2018,
Roman Signer. Spuren, exhibition view, Kunstmuseum St. Gallen, 2018

Acknowledgments

This book initially took inspiration from the unusually sensitive and profound insight into the heart of an art collection, provided by reading interviews with Giuseppe and Giovanna Panza. Similarly personal conversations, conducted over a period of several months, seemed to me a suitable path to take in learning about the origins and history of Ursula Hauser's passion for collecting. It is such a privilege that she ultimately agreed to converse with us about her love of art, all the more so, as she shies away from public appearances and is ordinarily not one to talk about herself.

I am deeply indebted to my co-editor Laura Bechter. She responded to the idea of embarking on this project with great enthusiasm. Her in-depth knowledge of the collection's acquisitions history and the individual artists was indispensable to understanding the growth, dynamics, and specific highlights of the collection.

Together, we wish to express our heartfelt thanks to Manuela and Iwan Wirth for their unconditional encouragement and support of our project. Ursula Hauser's story is theirs as well, the story of a family of art dealers, artists, and collectors who enjoy an astonishingly close exchange, undaunted by geographical distance. Family members find innumerable opportunities to meet and keep one another informed by speaking several times a day. In fact, the phone would frequently ring even during our conversations with Ursula Hauser.

Obviously, our greatest gratitude goes to Ursula Hauser herself. She willingly engaged in these personal conversations with us. In her, we found an extraordinarily open, enthusiastic, and yet realistic, modest, loving, and attentive human being. Her door was always open to us, just as it is for all of her artists. Lunch included! It has been an unadulterated joy to work on this book project. Thank you, dear Ursula, thank you for your unstinting hospitality and trust!

We sincerely hope that this book will provide art lovers access to an outstanding private collection and the passion that forges it. Who knows, perhaps it will be an inspiration for readers to discover their own very personal passion for art and collecting.

Michaela Unterdörfer

Ida Applebroog *1929
Group C #3
1969
Ink on paper
12 × 9 in. (30.5 × 22.9 cm)
p. 162

Group C #4
1969
Ink on paper
12 × 9 in. (30.5 × 22.9 cm)
p. 162

Group C #5
1969
Ink on paper
12 × 9 in. (30.5 × 22.9 cm)
p. 162

Group C #10
1969
Ink on paper
12 × 9 in. (30.5 × 22.9 cm)
p. 162

Group C #11
1969
Ink on paper
12 × 9 in. (30.5 × 22.9 cm)
p. 162

Group C #13
1969
Ink on paper
12 × 9 in. (30.5 × 22.9 cm)
p. 162

Stefan Banz *1961
You Can Spend Your Time Alone
1996
Color photograph on aluminum
63 × 94 ½ in. (160 × 240 cm)
p. 54

Phyllida Barlow *1944
RIG: untitled; pompoms
2011
Fabric and paper, 16 parts
Overall installed dimensions:
109 × 341 × 316 ⅞ in.
(277 × 866 × 805 cm)
p. 118

untitled: awnings 4 (yellow)
2013
Acrylic on watercolor paper
22 × 29 ⅞ in. (56 × 76 cm)
p. 167

untitled: stack
2015
Plywood, timber, wire mesh,
scrim, cement, sand, polyure-
thane foam, PVA, paint, steel,
and concrete
Overall dimensions:
142 ⅛ × 141 ¾ × 181 ⅛ in.
(361 × 360 × 460 cm)
Sculpture: 89 ⅜ × 64 ⅛ × 54 ¾ in.
(227 × 163 × 139 cm)
Panel: 142 ⅛ × 141 ¾ × 27 ⅛ in.
(361 × 360 × 69 cm)
p. 167

untitled: folly; baubles; 2016/2017
2016–17
Cardboard, cement, foam, paint,
paper, plywood, polycotton,
polyurethane board, polystyrene,
polyurethane foam, spray paint,
steel, varnish, and wire mesh
Various heights; overall
approximate footprint:
795 ⅝ × 314 ⅛ in.
(2021 × 798 cm)
p. 168

Louise Bourgeois 1911–2010
Maisons Fragiles
1978
Steel, 2 parts
Taller part: 84 × 27 × 14 in.
(213.3 × 68.5 × 35.5 cm)
Shorter part: 72 × 27 × 14 in.
(182.8 × 68.5 × 35.5 cm)
p. 76

Legs
1989
Rubber, 2 parts
Each part: 123 × 2 × 2 in.
(312.5 × 5.1 × 5.1 cm)
p. 68

Untitled (Mirror)
1995
Ink and watercolor on paper
11 ⅞ × 9 in. (30.2 × 22.9 cm)
Cover, p. 1

Spider
1996
Steel
128 × 298 × 278 in.
(325 × 757 × 706 cm)
Jacket, pp. 72-73

Passage Dangereux
1997
Mixed media
103 ⅞ × 140 × 345 ⅛ in.
(264 × 355.6 × 876.6 cm)
p. 71

The Good Mother (Topiary)
1999
Patinated steel, beads,
wood, wire, and cloth
ca. 13 ¾ × 7 ⅞ × 7 ⅞ in.
(35 × 20 × 20 cm)
p. 75

Heidi Bucher 1926–1993
Borg
1976
Textile, latex, mother of
pearl pigments, and bamboo
90 ½ × 137 ¾ × 39 ⅜ in.
(230 × 350 × 100 cm)
p. 142

Weissleimhaus (Glue House)
1983
Polyvinyl acetate glue, foam,
textile, and white color
20 ½ × 20 ⅞ × 7 ⅞ in.
(52 × 53 × 20 cm)
p. 142

Die Quelle (The Source)
1987
Vase, metal, textile, glue,
and color
137 ¾ × 590 ½ in.
(350 × 1500 cm)
p. 141

Eduardo Chillida 1924–2002
Oxido 78 (Oxide 78)
1983
Chamotte clay and copper oxide
27 ¾ × 22 ¼ × 3 ⅞ in.
(70.5 × 56.5 × 10 cm)
p. 51

Martin Creed *1968
Work No. 2197
2015
Emulsion on wall
Dimensions variable
Jacket

Berlinde De Bruyckere *1964
Hanne, 2003
2003
Wax, horsehair, epoxy, wood,
iron, and resin
68 ⅞ × 20 ½ × 23 ⅝ in.
(175 × 52 × 60 cm)
p. 153

Piëta, 2008
2008
Wax, epoxy, metal, and wood
63 ⅝ × 27 ⅜ × 31 ⅛ in.
(161.5 × 69.5 × 79 cm)
p. 156

Courtyard tales, 2017–2018
2018
Blankets, wood, polyure-
thane, and epoxy
108 ¼ × 106 ¼ × 16 ½ in.
(275 × 270 × 42 cm)
p. 154

Dan Graham *1942
*Two Joined Cubes (Dedicated
to Roy Lichtenstein)*
1996–97
Stainless steel and dark glass
90 ½ × 263 ¾ × 145 ⅝ in.
(230 × 670 × 370 cm)
p. 46

Mary Heilmann *1940
*1st Three For Two: Red,
Yellow, Blue*
1975
Acrylic on canvas
57 ¼ × 35 ¼ × 2 ½ in.
(145.4 × 89.5 × 6.4 cm)
p. 66

Chinatown
1976
Acrylic on canvas, 2 parts
Each part: 83 ⅞ × 54 × 2 ¾ in.
(213 × 137.3 × 7 cm)
p. 66

Montauk Surf (for Ursula)
2009
Oil on canvas
11 ¾ × 9 × ⅝ in.
(30 × 23 × 1.5 cm)
p. 65

Eva Hesse 1936–1970
No title
1960
Oil on canvas
49 ½ × 49 ½ × 1 ½ in.
(125.7 × 125.7 × 3.7 cm)
p. 81

Oomamaboomba
May 1965
Tempera, enamel, rope, cord,
metal, modeling compound
(glue plaster, wood shavings),
particle board, and wood
22 × 25 ⅝ × 5 ⅛ in.
(56 × 65 × 13 cm)
Board: 21 ¼ × 25 ⅝ × 2 ¾ in.
(54 × 65 × 7 cm)
p. 82

Roni Horn *1955
Untitled, No. 2
1999
2 Iris-printed photographs
on Somerset paper
Each: 22 × 22 in. (55.9 × 55.9 cm)
p. 128

Rings of Lispector (Agua Viva)
2004
Natural rubber, with text
inserts of orange colored rubber
Each tile: 68.9 sq. in. (1.75 sq. m)
p. 126

Water, Selected
2007
24 glass columns
filled with water from unique
glacial sources
Overall dimensions:
approx. 250 sq. ft. (23.2 m²)
Each column: diameter 12 in.
(30.5 cm), height 110 in.
(279.4 cm)
Permanent installation at
Vatnasafn / Library of Water,
Stykkishólmur, Iceland
p. 128

You are the Weather (Iceland)
2007
Solid rubber with rubber
text inlay
Overall dimensions:
approx. 250 sq. ft. (23.2 m²)
Each tile: 49 × 49 × 1 in.
(125 × 125 × 3 cm)
Permanent installation at
Vatnasafn/Library of Water,
Stykkishólmur, Iceland
p. 128

Richard Jackson *1939
1000 Clocks
1987–92
Steel, aluminum, electronic
parts, plastic, fluorescent
lights, oil, and paint
141 ¾ × 432 ¼ × 360 ¼ in.
(360 × 1098 × 915 cm)
p. 176

Ballerina in a Whirlpool
1996
Fiberglass, polyester resin,
washing machine, sink,
steel, pump, and plastic
120 × 27 × 55 in.
(304.8 × 68.6 × 139.7 cm)
p. 174

Nicola L. 1937–2018
Foot Sofa
1968
Vinyl and filling material
25 × 67 × 23 in.
(63.5 × 170.2 × 58.5 cm)
p. 180

Planet Eye
1968–2014
Plexiglas
28 ½ × 35 ½ × 13 in.
(72.4 × 90.2 × 33 cm)
p. 180

Maria Lassnig 1919–2014
Die rasende Grossmutter
(*The Racing Grandmother*)
1963
Oil on canvas
37 ⅜ × 50 ¾ in. (95 × 129 cm)
p. 149

Augenmensch (Eye Person)
1992
Oil on canvas
49 ¼ × 39 ⅜ in. (125 × 100 cm)
p. 150

Lichtkoffer (Light Case)
1993
Oil on canvas
78 ¾ × 57 ⅛ in. (200 × 145 cm)
p. 173

Sprachgitter (Language Mesh)
1999
Oil on canvas
80 ¾ × 59 in. (205 × 150 cm)
p. 149

Mann, Frau und Hund
(*Man, Woman, and Dog*)
2010
Oil on canvas
59 × 82 ⅝ in. (150 × 210 cm)
p. 150

Lee Lozano 1930–1999
No title
1963
Oil on canvas
96 ¼ × 66 ⅛ × 1 ⅞ in.
(244.6 × 168 × 4.8 cm)
p. 147

Paul McCarthy *1945
Forests
1984
Charcoal and watercolor
on paper
87 × 122 ⅞ in. (221 × 312 cm)
p. 107

Apple Heads on Swiss Cheese
1997–99
Fibreglass and silicone, 2 parts
Part 1/2: 145 ⅝ × 74 ¾ × 59 in.
(370 × 190 × 150 cm)
Part 2/2: 145 ⅝ × 60 ¼ × 59 in.
(370 × 153 × 150 cm)
p. 106

Apple Heads on Swiss Cheese
1998
Pencil on transparent paper,
pencil on paper (verso sketch
for Dead H Crawl), 5 parts
4 parts, each: 23 ⅞ × 19 ¼ in.
(60.7 × 48.8 cm)
1 part: 11 × 8 ½ in.
(27.9 × 21.6 cm)
p. 106

Model for 'Apple Heads'
1998
Plaster, wood, and metal, 3 parts
Male figure: 28 ⅛ × 16 ⅞ ×
19 ¼ in. (71.5 × 43 × 49 cm)
Female figure: 27 ½ × 15 ½ ×
16 ⅞ in. (70 × 39.5 × 43 cm)
Apple: 14 ⅝ × 17 ⅜ × 16 ⅛ in.
(37 × 44 × 41 cm)
p. 106

KKKKK
2009
Wax, armature, wire, and wood
19 ½ × 10 ⅜ × 7 ⅞ in.
(49.5 × 26.5 × 20 cm)
pp. 66, 107

White Snow Dwarves
(*Dopey #1, Doc, Sleepy, Sneezy,
Happy, Bashful, Dopey #2,
Sleepy #1 [Midget], Grumpy*)
2010–12
Group of 9 sculptures; silicone
(silver, red, white, brown, black,
flesh color, gold, blue, and pink)
71 ⅜ × 48 × 48 in.
(181.3 × 121.9 × 121.9 cm);
67 × 50 × 48 in. (170.2 × 127 ×
121.9 cm); 68 ¼ × 62 × 61 ½ in.
(173.4 × 157.5 × 156.2 cm);
66 × 62 × 61 in. (167.6 × 157.5 ×
154.9 cm); 73 × 48 × 48 in.

(185.4 × 121.9 × 121.9 cm);
66 × 48 × 48 in. (167.6 × 121.9 ×
121.9 cm); 71 × 48 × 48 in.
(180.3 × 121.9 × 121.9 cm);
56 ½ × 48 × 48 in. (143.5 ×
121.9 × 121.9 cm); 67 ½ × 59 ×
51 ¾ in. (171.5 × 149.9 × 131.4 cm)
p. 104

Meret Oppenheim 1913–1985
Pelzhandschuhe (*Fur Gloves
with Wooden Fingers*)
1936
Fur gloves, wooden fingers,
and nail polish
2 parts, each: 2 × 8 ¼ × 3 ⅞ in.
(5 × 21 × 10 cm)
pp. 122–123

Hafer-Blumen (*Oat Flowers*)
1969
Plastic flower, oats, and
paper label
4 ¾ × 19 ⅝ × 5 ½ in.
(12 × 50 × 14 cm)
p. 124

Francis Picabia 1879–1953
Double Soleil (*Double Sun*)
1950
Oil on cardboard mounted
on Pavatex plate
69 ¼ × 49 ¼ in. (175.8 × 125 cm)
p. 99

Villejuif
1951
Oil on plywood
58 ⅞ × 37 ⅜ in. (149.5 × 95.5 cm)
p. 99

Carol Rama 1918–2015
Epifania
2003
Oil, enamel, and pastel on
sandpaper
33 ⅞ × 28 in. (84 × 69.5 cm)
p. 138

Jason Rhoades 1965–2006
*The Future Is Filled with
Opportunities (Ridable Steer)*
1995
Go-ped, ABS pipe, petrol engine,
buckets with lid, tie-down,
lasso, buckets, longhorn horns,
flashlight, screws, and nuts
36 × 42 × 48 in.
(91.4 × 106.7 × 121.9 cm)
p. 102

Pipilotti Rist *1962
Elektrobranche (*Pipilampi grün*)
1993
Lampshade, lightbulb, bulb
fitting, hanger, and swimsuit
29 ⅞ × 15 × 15 in.
(76 × 38 × 38 cm)
p. 116

Pamela
1997
Video installation, 1 player,
1 LCD plasma monitor, and
sound with Anders Guggisberg
Duration: 4' 05"
p. 117

Regenfrau (*I Am Called a Plant*)
1998–99
1 fitted kitchen with floor to
ceiling cupboards, 1 projection,
1 player, 1 audio system
Dimensions variable
p. 117

Dieter Roth 1930–1998
Bar 2 (with Björn Roth)
1983–97
Mixed media
Dimensions variable,
ca. 157 ½ × 236 ¼ × 98 ⅜ in.
(400 × 600 × 250 cm)
p. 57

Roman Signer *1938
Kraft des Regens I
(*Power of Rain I*)
1974
Aluminum funnel, PVC hose,
rubber hose, rubber bag, 4 metal
plates, rainwater, and drawing
56 ¾ × 35 ⅜ × 30 ¾ in.
(144 × 90 × 78 cm)
Iron construction:
56 ¾ × 35 ⅜ × 30 ¾ in.
(144 × 90 × 78 cm)
Iron plates, each 17 ¾ ×
11 ¾ × ⅜ in. (45 × 30 × 1 cm)
p. 89

Kraft des Regens (*Power of Rain*)
1975
Watercolor and ink on paper
11 ¾ × 16 ⅝ in.
(29.7 × 42.2 cm)
p. 89

Eisentor (*Iron Gate*)
1980
Iron
86 ⅝ × 43 ¼ × 39 ⅜ in.
(220 × 110 × 100 cm)
p. 86

Ballon (*Balloon*)
1982
Pencil, India ink and
watercolor on paper
11 ⅝ × 16 ½ in.
(29.5 × 42 cm)
p. 191

Wasserturm (*Water Tower*)
1987
Installation
p. 85

Blaues Fass: Schneise im Feld
(*Blue Barrel: Field Row*)
1999/2018
Installation
p. 191

Piaggio on Jump (Poland)
2003
4 C-prints
Each: 15 ¾ × 23 ⅝ in.
(40 × 60 cm)
p. 90

Michel Sima 1912–1987
Portrait of Picabia
n.d.
Black and white photograph
11 ¾ × 15 ¾ in. (30 × 40 cm)
p. 97

Sylvia Sleigh 1916–2010
Working at Home
1969
Oil on canvas
56 × 32 in. (142.2 × 81.3 cm)
p. 186

Diana Kurz
1978
Oil on canvas
36 × 24 in. (91.4 × 61 cm)
p. 186

Loredana Sperini *1970
Untitled
2012
Wax, cement, and pigment
21 ⅞ × 19 ⅝ × 13 ¾ in.
(55.5 × 50 × 35 cm)
p. 178

Untitled
2016
Wax, cement, and pigment
26 ⅝ × 32 ⅝ × 29 ⅞ in.
(67.5 × 83 × 76 cm)
p. 178

Alina Szapocznikow 1926–1973
Bouches en Marche
(Mouths on the Move)
1966–70
Bronze patinated with gold
13 ¾ × 9 ½ × 9 ⅞ in.
(35 × 24 × 25 cm)
p. 120

Jeu de galets (Pebble Game)
1967
Bronze, 17 polished stones
2 ⅜ × 13 ⅜ × 22 ⅞ in.
(6 × 34 × 58 cm)
p. 130

Ventre-coussin (belly cushion)
1968
Polyurethane foam
7 ⅛ × 11 ¾ × 13 ⅜ in.
(18 × 30 × 34 cm)
p. 132

Stela (Stéle)
1968
Polyester resin and
polyurethane foam
31 ⅛ × 18 ⅛ × 27 ⅛ in.
(79 × 46 × 69 cm)
p. 132

Dessert V
1970
Polyester, color photographs
9 × 6 ¼ × 7 ½ in.
(23 × 16 × 19 cm)
p. 132

Fotorzeźby (Photosculptures)
1971/2007
Gelatin silver prints on
baryte paper, 20 parts
Each: 11 ¾ × 9 ½ in.
(30 × 24 cm)
p. 134

Richard Wentworth *1947
World Soup
1991
Galvanized steel with tin cans
4 ½ × 29 ⅛ × 28 ⅛ in.
(11.5 × 74 × 71.5 cm)
p. 48

Franz West 1947–2012
Lemurenköpfe (Lemur Heads)
1992
Aluminum coated with white
dispersion primer, 2 parts
Part 1/2: 98 ⅜ × 39 ¾ ×
44 ½ in. (250 × 101 × 113 cm)
Part 2/2: 95 ⅝ × 29 ½ × 50 ¾ in.
(243 × 75 × 129 cm)
p. 95

Rest
1994
28 divans: iron, rubber foam,
and fabric (Textile design:
Gilbert Bretterbauer)
Each bench: 39 ⅜ × 94 ½ ×
33 ½ in. (100 × 240 × 85 cm)
p. 95

Am 28. (On 28th)
1999
Overpainted photocopy collage
11 ⅝ × 8 ½ in. (29.5 × 21.7 cm)
p. 95

Mädy Zünd 1916–1998
Ohne Titel (Paar)
(Untitled (Couple))
n.d.
Fired clay
13 ⅞ × 8 ½ × 4 ⅜ in.
(35.2 × 21.5 × 11 cm)
p. 30

pp. 66, 71, 95 (top right), 107, 118–124, 128 (bottom), 132, 142 (bottom), 153, 167 (top right), 186, 189: Stefan Altenburger Photography Zürich; p. 191 (bottom): Daniel Ammann; pp. 142 (top), 173 (top), 174, 176 (bottom): Aufdi Aufdermauer/ videocompany.ch; p. 29: Archive Bühler AG; p. 45 (top): Archive Dipl. Ing. Fust AG, Oberbüren; p. 165: Thierry Bal; p. 177: Goran Basic/NZZ, 2017; p. 36: Ralph Bensberg, ©ETH Library Image Archive; p. 168: Ruth Clark, ©British Council; p. 167 (bottom): Alex Delfanne; p. 58 (bottom): Pouran Esrafily; p. 176 (top): Tristan Fewings; p. 144 (bottom): ©FILAF 2018 – International Art Book and Film Festival, Perpignan (France); p. 147: Hollis Frampton; p. 45 (bottom): Archive Walter Fust, Bern; p. 16 (top): Municipal Archive Uzwil: Estate Mario Klaus, (bottom): Municipal Archive Uzwil; p. 89: Barbora Gerny; p. 137: Roberto Goffi; p. 95 (bottom): Melissa Goldstein, Courtesy Dia Art Foundation, New York; p. 138: Genevieve Hanson; pp. 12–13, 18–26, 29 (bottom), 32–35, 38–42, 52 (top), 54, 58 (top), 60–63, 65, 86, 90 (top), 100, 102–104, 114 (bottom), 126 (left), 155, 159, 167 (top left), 183: Ursula Hauser Archive; pp. 75–76, 81–82, 95 (top left), 99, 106–107, 116, 117 (top), 128 (top), 130, 149 (bottom), 180, 191 (top): Ursula Hauser Collection Archive; pp. 52 (bottom), 111, 113, 126 (right), 149 (top): Hauser & Wirth Archive; p. 46 (bottom): Giorgio Hoch; p. 144 (top): Vera Isler, ART Nachlassstiftung, Bern; p. 178 (bottom): Daniele Kaehr; p. 156: Jussi Koivunen; p. 147 (bottom): © The Estate of Lee Lozano, Courtesy Hauser & Wirth; p. 173 (bottom left): Katharina Lütscher; p. 92 (bottom): Mancia/ Bodmer; p. 85: Philippe Maussion; p. 68: Piermarco Menini; p. 51: Frederic Meyer; p. 162 (top): Emily Poole; p. 46 (top): Raussmüller; p. 102: Courtesy The Estate of Jason Rhoades, Hauser & Wirth and David Zwirner, New York/London/Hong Kong; p. 48 (bottom): Gerhard Richter Archiv; p. 117: Courtesy the artist and Hauser & Wirth; pp. 184–185: Lenora Seroka, ©Getty Research Institute, Los Angeles (2004. M.4); p. 90 (bottom): Rudolf Steiner/videocompany.ch; p. 97: Comité Michel Sima; pp. 72–73: Matthias Soeder, www.palmpix.com; p. 178 (top): Sebastian Stadler; p. 92 (top): Niklaus Stauss; p. 30: Michaela Unterdörfer; pp. 154, 170: Clare Walsh; p. 114 (top): Jamie Watts; p. 141: Ben Westoby; p. 150 (bottom): Jens Ziehe, Berlin

Jacket photographs: Ursula Hauser's living room with Louise Bourgeois, *Spider,* 1996, photo by Matthias Soeder; Ursula Hauser in front of Martin Creed, Work *No. 2197,* 2015, photo by Axel Dupeux

Cover image: Louise Bourgeois, *Untitled (Mirror),* 1995

Every effort has been made to trace copyright ownership and to obtain reproduction permissions. Corrections brought to the publisher's attention will be incorporated in future reprints or editions of this book.

Colophon

Editors: Laura Bechter and Michaela Unterdörfer
Book design: Iza Hren
Editorial coordination: Jennifer Stenger
Project assistant: Carmen Reichmuth
Translator: Catherine Schelbert
Proofreading: Sara Harrison
Image reproductions: Widmer & Fluri GmbH, Zurich
Lithography, printing, and binding: DZA
Druckerei zu Altenburg GmbH, Thuringia

We would like to thank all those who
contributed to this book.

*The Inner Mirror: Conversations with
Ursula Hauser, Art Collector*
© 2019 Hauser & Wirth Publishers
www.hauserwirth.com

Unless otherwise stated, all work © the artist

For the work of Heidi Bucher: © The Estate of
Heidi Bucher; Eduardo Chillida: © Zabalaga-Leku;
Eva Hesse: © The Estate of Eva Hesse; Maria
Lassnig: © Maria Lassnig Stiftung; Lee Lozano:
© The Estate of Lee Lozano; Nicola L.: © The Estate
of Nicola L.; Meret Oppenheim: © The Estate of
Meret Oppenheim; Francis Picabia: © The Estate
of Francis Picabia; Carol Rama: © Archivio Carol
Rama; Jason Rhoades: © The Estate of Jason Rhoades;
Dieter Roth: © Dieter Roth Estate; Michel Sima:
© Comité Michel Sima; Sylvia Sleigh: © The Estate
of Sylvia Sleigh; Alina Szapocznikow: © The Estate
of Alina Szapocznikow; Franz West: © Estate
Franz West

For works by Louise Bourgeois: © The Easton
Foundation/2019, ProLitteris, Zurich

For works by Bruce Nauman: © Bruce Nauman/
2019 ProLitteris, Zurich

For works by Eduardo Chillida, Martin Creed,
Meret Oppenheim, Alina Szapocznikow, and
Richard Wentworth: © 2019 ProLitteris, Zurich

All works courtesy Ursula Hauser Collection,
Switzerland, excluding: p. 46 (top): Raussmüller;
pp. 51, 92 (bottom), 118, 126, 142 (top), 168:
Private collections; p. 85: City of St. Gallen; p. 95
(bottom): Courtesy the artist and Hauser & Wirth
and David Zwirner, New York/London/Hong Kong;
p. 100 (top): Courtesy David Zwirner; p. 102 (top):
Courtesy The Estate of Jason Rhoades, Hauser &
Wirth and David Zwirner, New York/London/
Hong Kong; p. 128: Courtesy Vatnasafn/Library of
Water, commissioned and produced by Artangel;
p. 141: The Estate of Heidi Bucher; p. 154: Courtesy
the artist and Hauser & Wirth

Cataloguing-in-Publication Data is available
from the Library of Congress.

Available through
ARTBOOK | D.A.P.
75 Broad Street, Suite 630
New York, NY 10004
Tel 212 627 1999 | Fax 212 627 9484

English edition published by
Hauser & Wirth Publishers
ISBN 978-3-906915-38-8

German edition made in cooperation
with Scheidegger & Spiess
ISBN 978-3-85881-631-3

Printed and bound in Germany